Peatlands of Ohio and the Southern Great Lakes Region

Peatlands of Ohio and the Southern Great Lakes Region

Guy L. Denny

with photographs from **Gary Meszaros**

The Kent State University Press KENT, OHIO

© 2022 by The Kent State University Press, Kent, Ohio 44242
All rights reserved
ISBN 978-1-60635-437-7
Manufactured in Korea

Cataloging information for this title is available at the Library of Congress.

26 25 24 23 22 5 4 3 2 1

Contents

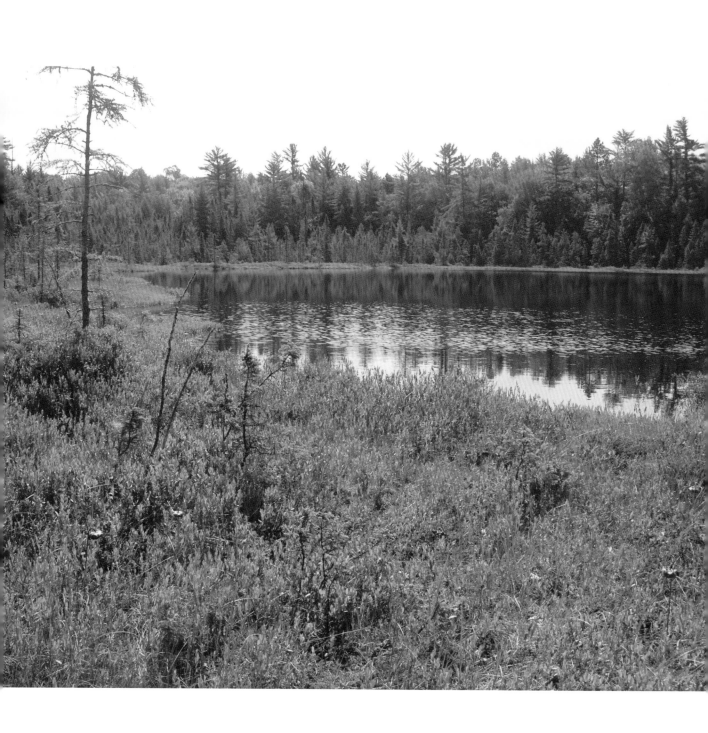

Introduction

Peatlands, and specifically bogs, have always been a source of fascination for humans, especially in ancient times for the people of Ireland and Western Europe where sprawling peatlands compose a significant part of the landscape. To these ancient Celtic and Germanic peoples, bogs were mystical, sacred, and even frightening places where it was believed humans could connect with deities. The term *bog* appears to have originated with the Irish Celts, whose word for bogs was thought to be *bocc,* meaning "soft," which understandably is a good description of peatlands even today (Johnson 1985). The Celts were people of the Bronze and Iron Ages who primarily inhabited what is now Great Britain, Ireland, Scotland, and northern Germany. Their lives were closely entwined with the sprawling peatlands of these countries.

In today's world, peatlands are no longer feared; rather, peatland ecosystems are great fun to explore. In different areas of the world, peatlands might have other common names, such as mires, moors, muskegs, heaths, and, in the southeastern United States, pocosins. They are an endless source of discovery, beauty, and fascination for scientists and amateur nature lovers alike.

This book focusses on the kettlehole sphagnum peat bogs and rich alkaline fens of the southern Great Lakes region, south of what is considered the boreal forest region of Canada. Our main emphasis will be on the Wisconsinan glaciated southern, lower Great Lake states of Illinois, Indiana, Ohio, the southern half of Michigan, and the glaciated northern corners of Pennsylvania.

However, to a lesser extent, we will also take into consideration the same kinds of peatlands occurring in the upper Great Lake states of Minnesota, Wisconsin, the northern half of Michigan, and the Adirondack region of New York. These latter four states are situated within the conifer/northern hardwoods forest zone of the Great Lakes region where the climate is more

Facing page: Cranberry Lake is a typical kettlehole lake sphagnum peat bog, one of many, in Hiawatha National Forest in the Upper Peninsula of Michigan. (Photo by Guy L. Denny.)

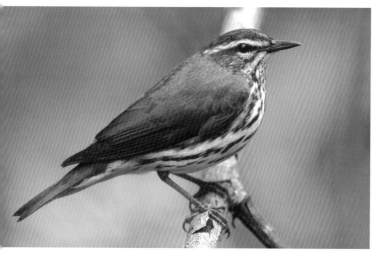

An inhabitant of black spruce muskegs, northern water-thrushes (*Seiurus noveboracensis*) reach the southern edge of their breeding range in southern Michigan and New York. (Photo by Gary Meszaros.)

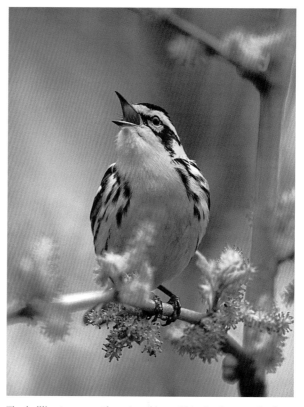

The brilliant orange throat and broad black wing patch of the blackburnian warbler (*Dendroica fusca*) are a sight not to be forgotten. This beautiful species breeds in coniferous and mixed forests. (Photo by Gary Meszaros.)

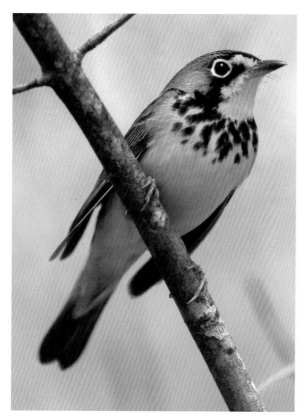

An inhabitant of boreal forests, Canada warblers (*Wilsonia canadensis*) are common breeders often feeding in low, dense foliage. (Photo by Gary Meszaros.)

A common breeding songbird in northern peatlands, mourning warblers (*Oporornis philadelphia,* a.k.a. *Geothlypis philadelphia*) are one of the latest warblers to arrive on their breeding grounds. (Photo by Gary Meszaros.)

conducive to boreal species of plants and animals. Gradually, this zone then grades northward into the boreal forest region of Canada.

This book is not intended to be a scientific treatise covering all the peatlands of North America. That would be complex and probably beyond the scope of interest for most readers, who are very unlikely to ever experience all the various classifications of peatlands throughout the Northern Hemisphere. However, there are many publications listed in the bibliography that provide such detail. Howard Crum's *A Focus on Peatlands and Peat Mosses* and Charles W. Johnson's *Bogs of the Northeast* do a great job of detailing the boreal peatlands of the northeast United States and Canada. Rather, we are going to focus on the smaller disjunct-peatlands that are most commonly encountered around the southern Great Lakes region south of the boreal forest ecosystems of northeastern Minnesota and Canada. Canadian peatlands are far more extensive and more complex, and they are typically not confined to deep basins. They often cover thousands of acres, if not hundreds of square miles.

For the purposes of this book, we are going to largely ignore the generally accepted international classification system of peatlands. Instead, we are going to refer to those acidic peatlands that are based on a substrate of sphagnum

Located in west-central Ohio, Prairie Road Fen State Nature Preserve is an excellent example of a prairie fen. Notice the arching leafless stems of walking spike rush adjacent to the stream flowing through the sedge meadow. Both spotted turtles and massasauga rattlers are well established in this rich fen. (Photo by Guy L. Denny.)

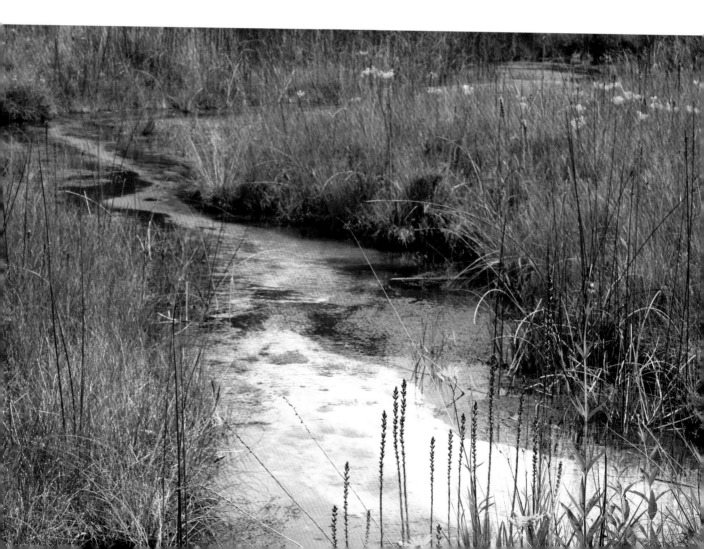

peat moss and confined to deep basins as kettlehole sphagnum peat bogs, just as they have always traditionally been called in this region of the country. As for mineral-rich alkaline fens, we will continue to call them rich fens. As you will see, rich fens and kettlehole sphagnum peat bogs are quite different from one another.

Peatlands and Peat

So exactly what are peatlands, and what is peat? Peatlands are a major type of wetland. Two non-peatland wetland classifications with which most people are familiar are marshes and swamps. Both of these classifications are wetlands based primarily on a nutrient-rich substrate of mineral soils, not peat. Marshes are open wetlands that support a growth of herbaceous floating and emergent vegetation such as water lilies, cattails, and pickerel weeds growing in standing water throughout the year. Swamps, however, have standing water most of the year, if not throughout the entire year, and support a forest growth of wetland trees such as pin oak (*Quercus palustris*), swamp white oak (*Q. bicolor*), and red maple (*Acer rubrum*), along with an understory of shrubs such as buttonbush (*Cephalanthus occidentalis*) and swamp rose (*Rosa palustris*).

In contrast, peatlands are ecosystems based on a substrate of peat and not mineral soils. Acid peatlands are called peat bogs and typically support a growth of *Sphagnum* mosses, sedges, and other rare boreal plants including various woody members of the Heath Family (Ericaceae). Peat bogs are typically contained within a deep water-filled basin. Fens are alkaline peatlands based primarily on a substrate of marl and are slightly acid to alkaline well-decomposed graminoid peat supporting a growth of sedges, rushes, grasses, and rare herbaceous plants, along with many woody species belonging to the Rose Family (Rosaceae). Fens are nourished by flowing alkaline groundwater. Kettlehole peat bogs are nourished by stationary acidic waters contained within a basin created when buried blocks of glacial ice melted, giving rise to deep lake basins known as kettlehole lakes.

Peat is an accumulation of partially decayed organic matter—especially peat moss, at least in northern latitudes. Peat is formed under acidic and water-logged anaerobic conditions whenever the rate of accumulation of organic

matter outpaces the rate of decay, allowing for only partial decomposition of organic matter and therefore a buildup of biomass. Peat is a precursor to coal. Peat formed in ancient coastal swamps during the Carboniferous Period between 298 and 358 million years ago and was then buried and compressed by massive overlying sediments for millions of years, ultimately converting the peat into coal.

Although we generally think of peatlands as occurring primarily in the Northern Hemisphere—such as in Canada, Russia, Northern Ireland, and Scotland, where peatlands are a significant part of the landscape—peatlands can also occur in more southern latitudes under wetland conditions where acidic and anaerobic conditions enable the accumulation of organic matter to exceed the rate of decay. Peatlands occur on all continents except Antarctica, from tropical to boreal conditions including high alpine environments.

Bog Bodies of Northern Europe

One of the features of peatlands that so fascinated the Celts is how bogs have "mystical powers" of preservation. The peatlands of northern Europe are much more acidic than those of the Great Lakes region and consequently not only is plant matter preserved in those peat deposits but just about anything else as well. In 1950, peat cutters working in a bog outside the small town of Silkeborg in Denmark uncovered a human body buried beneath about 7 feet of peat. The well-preserved body was in a fetal position with an animal-hide noose drawn tightly around his neck. Workers first thought they had come across a modern-day murder victim since the body was so well preserved. However, scientists using radiocarbon 14 dating learned that this man had died sometime between 375 and 210 BC, more than 2,300 years before their discovery. They named him Tollund Man. Tollund Man is the best-preserved, best-known, and perhaps most photographed of thousands of bog bodies that have since been uncovered in European bogs.

In 2011, a peat-mine worker in Cashel Bog in central Ireland discovered a human body in a bog that has since become known as Cashel Man. Although not as well preserved as Tollund Man, and unfortunately slightly dismembered by the peat-harvesting machinery that uncovered his body, radiocarbon dating revealed that Cashel Man lived during the early Bronze Age about 4,000 years ago. Bog bodies have been uncovered buried in peat bogs in several European countries, including Ireland, Denmark, the Netherlands, Scotland, Germany, and even Spain. Owing to the minor differences in bog chemistry, not all bodies discovered have been as exceptionally well preserved as Tollund Man and Cashel Man. Chemical processes associated with *Sphagnum* moss helped extract calcium from the bones of these buried bog bodies, leaving

mostly intact bodies with bog-tanned details of their skin, hair, and nails as well as preserved internal organs but little, if any, bone structure. In the case of Tollund Man, his head is so well preserved that whisker stubble and even skin pores are plainly visible.

Early on, it was thought that these victims were criminals who had been brutally executed and whose bodies were simply dumped into the bogs. However, prevailing thinking among most archaeologists now is that these individuals were victims of human ritualistic sacrifice. Many were thought to be regional kings who failed in their duties. In these cold, wet, northern climates, crops fail from time to time, and a king was believed by his subjects to have been responsible for such events, or at least responsible for not preventing such catastrophes (Glob 1969). To the Celts, a poor harvest meant a king had to be sacrificed to the gods in order to set things right. Most likely, there were probably few, if any, old kings in Celtic communities! However, notably among the thousands of bog bodies now recovered, the bodies of women and children were also discovered, along with such artifacts as swords and shields, precious ornaments, and even vats of butter.

Even into medieval times bogs remained mystical and frightening places; folklore and superstition persisted. Fueling some of these superstitious fears was a natural phenomenon known as will-o'-the-wisp, or, as the Irish called it, jack-o'-lantern. This was a mysterious flickering luminescence often observed hovering and moving around at night within bogs, swamps, and marshes and thought in folklore to be nefarious ghostly spirits. Unknown during that time in human history, these mysterious lights are a natural phenomenon of bioluminescence caused by the oxidation of methane gas produced by the anaerobic decay of peat. As small amounts of these gases escape into the atmosphere, they spontaneously ignite on contact with oxygen in the air producing a moving, soft bioluminescence varying in size from that of a candle flame to about that of the size of a human head.

The Pleistocene Ice Age

Peatlands occurring in today's northern latitudes are products of continental glaciation. Geologists tell us that the Earth has experienced at least five major ice ages over the past almost 3 billion years, the earliest known going all the way back to early Precambrian Time more than 2.3 billion years ago. The most recent global ice age, the Pleistocene Epoch, began 2.6 million years ago and is thought to have ended about 11,700 years ago. It was around this time that arctic ice caps and mountain glaciers began to expand and continental ice sheets started building and slowly began flowing southward down across the Northern Hemisphere. During the last glacial period there were alternating episodes of major glacier advances and retreats. These were interspersed with long periods of warm interglacial periods lasting thousands of years before the next major buildup of ice and major glacial advance.

Causes of Glaciation

There are many theories as to what causes an ice age, and there may be several factors involved. However, the current predominant theory has to do with slight variations in the Earth's long-term orbital parameters as first described by Dr. Milutin Milankovitch, a Serbian geophysicist. Milankovitch mathematically discovered the connection between cyclic fluctuations in Earth's orbital parameters in the 1920s. These included orbital eccentricity around the sun, changes in the angle that Earth's axis makes with the plane of Earth's orbit, and the change in the direction of the Earth's axis of rotation, all of which impact the distribution of solar radiation reaching the poles (Hays 1976). Together, the periods of these orbital motions known as Milankovitch cycles

are what most scientists now believe to be the main causes of ice ages. There may be other factors in play as well, such as cyclical variations in the sun's output, increases in atmospheric carbon dioxide levels, and changing ocean currents; however, Milankovitch cycles are currently believed to be the most significant factors.

Wisconsinan Glaciation

Each major glacial event is known as a glacial separated by warmer periods known as interglacials. Each advancing glacier left behind its own distinctively identifiable layer of glacial till. Glacial till is comprised of silt, sand, clay, gravel, rocks, and boulders that glacial ice picks up and then lays down as it moves across the land. The upper, more recent layers are only slightly weathered as compared to deeper, older layers that had been deeply chemically weathered prior to the deposition of younger overlying till. The various layers of till can be thought as somewhat like the layers of a cake, one astride the other.

Each glacier reworked the landscape, obscuring evidence of preceding glaciers except where those earlier glaciers extended well beyond the limits of the glaciers that succeeded them. Based on unobscured till deposits left behind, geologists historically recognized at least four major glacial events occurring during the last ice age in North America, each marked by their different-aged layers of till. Each major glacial event was named for the states in which the glacier's southernmost extension is known and their deposits best revealed and studied. The Nebraskan was the earliest, followed by the Kansan, the Illinoian, and the Wisconsinan Glacier—at least, that was the past thinking among geologists.

Geology, like all sciences, is constantly evolving. With more advanced and sophisticated scientific tools at their disposal, research geologists now tell us there appears to have been at least 11 major glacial events or glaciations as well as many minor glacial events prior to Illinoian glaciation. These new findings are based on more recent analysis of deep-sea sediment cores.

What Deep-Sea Sediment Cores Reveal

Ocean floor sediments are now used to determine past global climates, including glacial and interglacial periods. Using state-of-the-art mass spectrometers, scientists can analyze the isotopic composition of elements in a molecule of the calcium carbonate (also known as calcite) remains of singled-celled deep-sea marine organisms known as foraminifera. These tiny microorganisms have an

extensive fossil record dating from the present all the way back to the earliest Cambrian Period more than 500 million years ago. There are thousands of different species still living today in our oceans, and they are extraordinary abundant. As foraminifera develop and form their complex protective shells comprised of calcite or calcium carbonate ($CaCo3$), they extract oxygen molecules directly from seawater during this process.

Oxygen is a chemical element that naturally occurs in three forms. Two of the more common forms are stable isotopes oxygen-16 ($16O$) and oxygen-18 ($18O$). Both isotopes are the same element but have different atomic weight or mass numbers. An isotope is just a slight variation of an element at the atomic level. In a stable element, the number of protons (positive charges) in an element balance those of the number of neutrons (neutral charges). However, the number of neutrons may differ. In the case of oxygen, oxygen-16 has eight protons and eight neutrons. This is known as light oxygen and constitutes about 99 percent of all oxygen in the air. Heavy oxygen has eight protons and 10 neutrons. Therefore, the oxygen-18 isotope is two neutrons heavier than oxygen-16, which causes the water molecule in which it occurs to be slightly heavier.

Each year as foraminifera die, their shells sink to the ocean floor and build up annual layers in ocean sediments. Marine sediments can be composed primarily of the remains of these organisms. By sampling layers of sediments from the seafloor and then using a mass spectrometer to determine the ratio of oxygen-16 to oxygen-18 isotopes in the discarded $CaCO3$ shells, scientists can determine past climates based on ocean temperatures at the time the shells were being formed. Molecules comprised of oxygen-16 being lighter than those comprised of oxygen-18 mean they evaporate faster into atmospheric moisture. When oceans are cold during a glacial event, the ratio of oxygen-18 isotopes in seawater is much greater because much of the oxygen-16 isotopes evaporate faster and end up in land-based glacial ice, leaving mostly the heavier oxygen-18 isotopes behind in the ocean. Conversely, during warm interglacials, glacial ice melts, releasing oxygen-16 back into the ocean. These meltwaters then increase the ratio of oxygen-16 isotopes to oxygen-18 isotopes. This ratio of the two oxygen isotopes is reflected in the composition of foraminifera shells because they utilize more of whichever oxygen isotopes are more abundant at the time their shells are being formed. Consequently, foraminifera shells formed during ice age glaciations have a higher ratio of oxygen-18 isotopes than oxygen-16 isotopes. Conversely, foraminifera shells formed during warm interglacial periods have a higher ratio of oxygen-16 isotopes. Using this chemical analytic methodology, geologists now have a much more accurate understanding of past glacial events than ever before and consequently of their impact on peatlands in northern latitudes.

The Development and Flow of Glacial Ice Southward

Inasmuch as peatlands occurring today throughout the Northern Hemisphere are relics of the Pleistocene and specifically the last major glaciation that took place within the Pleistocene, it helps to understand the connection between glaciation and the establishment of northern peatlands. During the most recent glaciation, which began around 70,000 years ago, once again the distribution of solar radiation reaching the poles was significantly reduced—due primarily to the cyclic fluctuations in Earth's orbital parameters. This resulted in cooler and shorter summers with minimum snowmelt and longer and colder winters with excessive snowfall. Snow continued to build up each year over thousands of years. As these snowfalls accumulated, growing in thickness, snow compressed by overlying countless layers of snow were ultimately transformed into glacial ice. Once glacial ice sheets build up to a thickness of about 200 feet, the enormous pressure of their own weight forces these giant masses to ooze outward at the edges in all directions, like pancake batter on a skillet. As the thickness continues to grow, these continental glaciers continue to flow outward and expand across the landscape. Continental glaciers have different names in different parts of the Northern Hemisphere. In North America, the last glacial or glaciation was the Wisconsinan continental glacier. This is the glacial event responsible for peatlands occupying the Northern Hemisphere of present-day North America.

In the Northern Hemisphere, the last continental glacial ice sheet did not form around the North Pole and then flow southward in all directions blanketing the Northern Hemisphere. Rather, ice packs built up more or less simultaneously in a number of centers, including northern Canada, Greenland, Northern Europe, and Siberia. In North America the continental glacier originating in Canada is called the Wisconsinan Glacier. Around the same time, the Weichselian Glacier was spreading across northern Europe and the Devensian continental glacier across Great Britain. The formation of continental glaciers during the last ice age was not solely restricted to the Northern Hemisphere. During this time in the Earth's history, continental glaciers were also forming and covering Antarctica while several mountain glaciers were also growing in size elsewhere within the Southern Hemisphere.

Although continental glaciers are formidable forces, significantly impacting the landscape over which they flow, they tend to move slowly. It is estimated that the Wisconsinan Glacier south of the Lake Erie Basin advanced at an average rate of about 160 feet a year, faster in some areas and slower in other areas (Goldthwait 1979). It took more than 6,000 years for the Wisconsinan Glacier to spread across what is now Lake Erie and Ohio. Of course, the glacial front would wax and wane depending on changing climatic conditions in the short term. Every now and then, when the weather warmed, the glacier halted

for perhaps a century or more and even receded, only to continue advancing during the return of cold weather.

As the Wisconsinan Glacier made its way south across North America, it crushed, buried, and erased all vegetation in its path. In doing so, it set the stage for peatland ecosystems to make their appearance in the Great Lakes region. As the glacier rounded off hilltops, filled valleys, and gouged out shallow basins, it picked up and incorporated silt, clay, sand, gravel, cobbles, and even huge boulders into the massive ice sheet. Geologists call this glacial drift. Huge boulders weighing several tons and randomly scattered across the countryside are known as glacial erratics. Most of these materials were directly deposited on the surface of the ground as the glacier moved across the landscape. These unsorted earthen materials directly laid down by the glacier are called glacial till. Where the glacier halted for very long periods, ice continued to flow southward out of the north, but the rate of ice flow was equal to melting along the ice front. As the ice melted, glacial till within the ice sheet was continually conveyed conveyor-belt style to the edge of the melting ice front and dumped in linear mounds often stretching many miles across the landscape. Such linear mounds of glacial till are known as end moraines. Some end moraines, depending largely on their composition, played a role in establishing and sustaining rich fens.

In addition to glacial till, fast-moving meltwaters within and emerging from the Wisconsinan Glacier sorted out glacial outwash that is comprised mostly of sand and gravel. As the ice sheets melted, outwash materials carried by meltwaters created outwash plains extending well beyond the edge of the melting ice sheet and deposited widely over the landscape in thick layers south of the glacier. Where pre-glacial river valleys occurred, they were often filled and buried by glacial outwash, forming exceptionally long extensions of largely porous gravel outwash materials called outwash valley trains. Aquifers of moving waters contained within these porous outwash valley trains play a major role in the occurrence and sustainability of modern-day, rich, fen ecosystems.

As the glacial ice melted, blocks of ice, some exceptionally large, broke free of the ice sheet and were buried by glacial outwash. Imbedded in an outwash plain and often underlain with impervious glacial till, these blocks of ice often persisted for very long periods of time before melting to form steep-sided, deep lakes and ponds called kettles, or kettlehole lakes. Not all kettle depressions filled with water, and not all became peatlands, but where conditions were suitable for peatland plants to colonize shorelines, those became the kettlehole sphagnum peat bogs of today. Frequently, bottom sediments in kettles are comprised of impervious clay layers lined with calcareous marl and overlain by peat. It would appear that these lakes started out as very alkaline bodies of water but later, because of the ability of *Sphagnum* mosses to acidify their environment, developed into acid sphagnum peat bogs. The

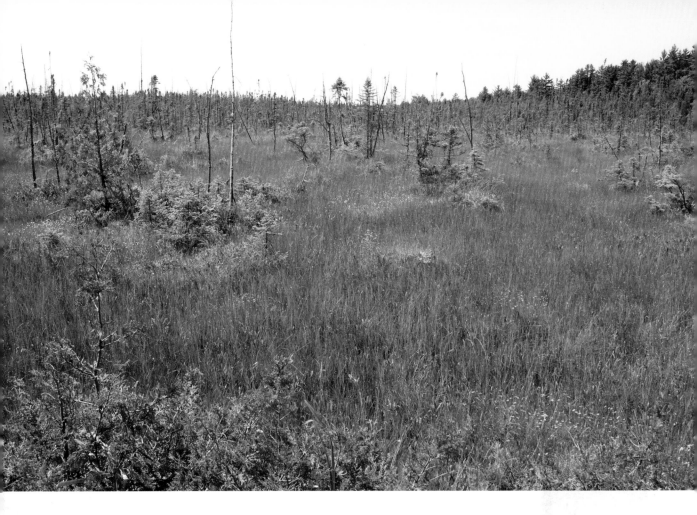

The rich fens in northern latitudes often have many of the same species as their southern Great Lakes region boreal fen counterparts, but they might look quite different overall, like Shingleton bog, actually an extensive rich fen, in the Upper Peninsula of Michigan. Typically, arbor vitae or northern white cedar trees are plentiful in these northern rich fens. (Photo by Guy L. Denny.)

Wisconsinan Glacier left behind thousands of ponds and glacial lakes on the newly exposed landscape as it melted northward. The shallower depressions were relatively short lived and most probably supported marsh vegetation or sedge meadow vegetation that favored calcareous substrates surrounded by forests of northern conifers, including mostly northern white cedar (*Thuja occidentalis*), black spruce (*Picea mariana*), and tamarack (*Larix laricina*).

These shallow wetland sites attracted grazing ice age megafauna like mastodons (*Mammut americanum*) and wooly mammoths (*Mammuthus primigenius*), two kinds of Pleistocene elephants that occasionally became mired and died in these glacial wetlands. Based on skeletal fossils, the mastodon was the more common. Most finds are made by farmers while draining low wet spots in their fields. These are former peat-filled depressions in shallow lakes created by the glacial ice. The generic name *Mammut* means "ground dweller" and reportedly has its origin in the Middle Ages when European farmers uncovered these huge bones in their fields and thought they were the remains of some sort of huge burrowing animal. Of course, that wasn't the case, but the scientific name stuck. Most finds in the Midwest have been of individual teeth washed out of peat deposits and discovered along streambeds.

Although both of these species were ice age elephants, they were two very different animals. The mammoth was the shaggier distant cousin of the mastodon, taller with a back that sloped downward from his rather high pointed head. The mastodon was smaller, with a stockier build and a relatively horizontal back. The most distinctive difference from their skeletal remains is their teeth. A mastodon's tooth was shaped somewhat like human teeth, with roots and pointed crowns. The mammoth's tooth was like that of a modern elephant. It looks like a large, solid, somewhat rectangular mass with a grinding surface of narrow enamel-coated plates tightly cemented together. Mammoths were more closely related to elephants of today, especially the Asian elephant. Both mammoths and mastodons, along with quite a number of other Pleistocene animals, became extinct at the end of the last ice age.

The front of the advancing wall of glacial ice was probably only 50 to 200 feet high, but it graded back to an estimated 5,000 to 8,000 feet thick over

Triangle Lake Bog in Portage County, Ohio, was formed by a huge block of imbedded ice that slowly melted away and created a large depression that gradually filled with water. (Photo by Gary Meszaros.)

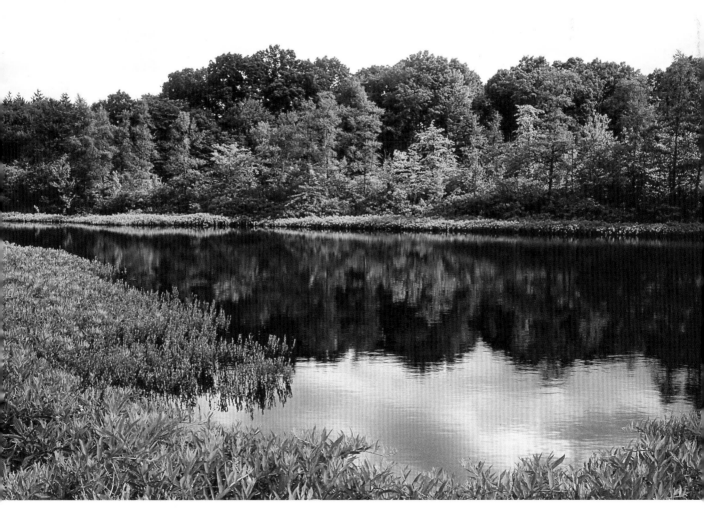

the Erie Basin (Forsyth 1963). The massive weight of the glacial ice pulverized earth and rocks beneath while rounding off sharp hilltops and partially filling valleys. In the process it totally obliterated and buried all vegetation in its path. Yet the ice sheet moved slowly enough to enable a wide band of boreal vegetation to precede the advancing front of the leading edge of the ice sheet southward. By the time the slowly lumbering glacier reached, crushed, and buried vegetation immediately in its path, offspring of these northern conifers and other associated boreal plants had become established well beyond the glacier. Nourished by cold, moisture-laden air and cold meltwaters from the distant glacial ice sheet, they were already producing seedlings of their own farther south of the glacier. In time, the offspring would share the fate of their parents. However, not before their own offspring, in turn, would reach maturity and produce offspring of their own even farther south of the glacial ice. In this manner, a band of newly established boreal vegetation always remained well in front of the advancing ice sheet. This process would work in reverse as glaciers retreated with global warming at the end of Wisconsinan glaciation.

Final Retreat of Glacial Ice

Although thick glacial ice would bury northern landscapes for thousands of years, around 18,000 years ago the global climate began a warming trend that ushered in the beginning of the end of the Pleistocene Epoch. While northern latitudes would remain colder, glacial ice continued to flow southward from its northern extremes. However, now it had warmed so much in southern latitudes that the southern margins of the ice sheet, as well as the surface of the glacier, were melting back so fast as to counter and exceed the flow of new ice moving down from the north. In the same way that glaciers wax and wane as they advance due to variations in climate over hundreds of years, they wax and wane during their final retreat northward. However, around 11,700 years ago, the glaciers began a final slow retreat northward. It is estimated that the ragged edge of the ice sheet may have melted back at an average of about 300 feet each year (Goldthwait 1979).

The same band of boreal vegetation that preceded the ice front would now retreat with the glacial ice sheet. As glaciers retreat, newly exposed barren, cold, wet glacial soils emerge from beneath the receding wall of ice for the first time in thousands of years. Such conditions provide an ideal habitat for boreal vegetation, including peatland vegetation, to colonize these newly exposed soils in close proximity to the glacial ice sheet. Boreal vegetation also quickly colonized the shorelines of countless meltwater lakes, ponds, and marshes left behind in the Wisconsinan Glacier's wake. However, as the glacier retreated farther and farther north, it had less and less influence on the

immediate landscape. Eventually temperatures warmed enough to displace and replace boreal vegetation with more southerly vegetation, including the deciduous temperate forest communities of today. Yet in some places where special environmental conditions allowed, remnant patches or communities of boreal vegetation continue to survive well south of their present-day range as living relics of the Ice Age. These include the peatlands, kettlehole sphagnum peat bogs, and rich fens of today.

Devensian Glaciation in Great Britain

At the same time that the Wisconsinan Glacier was advancing south out of Canada and into what is now the northern tier states, the Devensian Glacier of Great Britain was making its way southward across the British Isles. Like all glacial ice sheets, the enormous force of the Devensian Glacier altered the landscape over which it rode. Among other things, it gouged out large shallow basins that would later hold water in the form of shallow lakes and ponds. As the Devensian Glacier made its final retreat northward, the numerous extensive basins created during its advance southward now were exposed as places for boreal vegetation to quickly colonize in the wake of the retreating glacier. At first the shores of these shallow lake basins were colonized by peatland species such as sedges and bog-loving shrubs within a matrix of *Sphagnum* mosses. Within the next thousand years, layers of peat filled these basins at the exclusion of any open water, leaving only living sphagnum moss lawns covering the entire upper surface of what were originally large shallow lakes. *Sphagnum* moss can continue to grow upward but normally only as long as it is connected to a source of groundwater or surface water. Even then, its upward growth is limited to its ability to wick water upward by capillary water movement against frictional restraints and gravitational pull. Under most situations, once a peat mat reaches the upper limit of accessible groundwater, this ends the ability of the bog mat to continue to expand upward in thickness.

Unlike the southern Great Lakes region of North America that ultimately favors the colonization of more southern deciduous forest communities at the expense of boreal vegetation, the British Isles are situated much farther north, providing an advantage for the growth of boreal vegetation. More significantly, this part of the world, which includes Ireland, Scotland, England, Wales, and Denmark, is situated in close proximity to the Atlantic Ocean. In this oceanic or maritime cool climate—which is characterized by high year-round rainfall, dense fog, high humidity, and low evaporation rates—the growth of *Sphagnum* moss is favored. *Sphagnum* moss can continue expanding upward beyond normal limits, no longer relying on groundwater and surface runoff. Rather, *Sphagnum* moss depends on atmospheric moisture alone, which supplies these

peat bogs with needed moisture despite having only minimum nutrient levels obtained from rainwater and atmospheric dust. Now, completely disconnected from groundwater and surface waters, the sphagnum mat continues growing, building up a raised peat-bog surface transforming these bogs into what scientists classify as a domed or raised bog. They become what are referred to as ombrotrophic or rain-fed bogs. The word *ombrotrophic* comes from the Greek words *ombros,* meaning "rain," and *trophe,* meaning "food." According to an international, but somewhat generalized, system for classifying peatlands, raised bogs, which are totally disconnected from groundwater and surface runoff waters, are what peatland scientists consider to be the only true bogs.

Raised bogs build up to just a few feet or as much as 15 feet, sometimes even as much as 30 feet above the groundwater table so that they are no longer in contact with groundwater. The compacted impermeable layer of peat between groundwater levels and the upper active peat zone is known as the catotelm peat zone. There is a perched water table above this layer of impermeable peat in what is called the active peat zone or acrotelm. As long as the rate of decay does not exceed the rate of production of peat, the peat mass will continue growing upward. The high acid production in raised bogs not only makes them the most acidic of all peatlands with a pH of 3–4.0, but also they have low nutrient availability, a lack of oxygen, and cold peaty soils that restrict what plants can survive in such a harsh environment. Consequently, species diversity is low, and even those plants that can survive here are often undernourished and stunted. These are ideal conditions for preserving the bog bodies discovered in European raised bogs.

There are a number of different types of raised bogs based on their structure and physical settings, including eccentric bogs, domed concentric bogs, coastal plateau bogs, and blanket bogs. Most of these types occur frequently within more northern latitudes in both Europe and North America and within North America mostly in northern Maine, northward into and across Canada. Raised bogs tend to be better drained with more compacted peat than other peatlands. They are soft and moist at the surface but overall dryer and firmer just below the thin surface layer than other peatlands. For thousands of years, inhabitants of Western Europe, especially Irish, Danes, and Scottish peoples, have cut bricks of the underlying peat. These bricks have a consistency not unlike that of hard butter or modeling clay and are stacked and dried in spring. They are burned later for home heating and cooking. These bricks of peat are rich in organic carbon, which makes them an excellent fuel once dried. Initially, bog bodies were uncovered during such hand-digging peat-harvesting activities.

There have been various commercial uses for sphagnum peat moss over the years, including as a fuel, in building material, and as insulation. Today, while it is still used as a fuel in some countries, peat moss is mostly used in horticulture and agriculture for augmenting soil. Peat not only allows soils to

be lighter and more aerated and to hold more water, but also as peat decays, all the nutrients it robbed from the bog environment while it was growing are released back into the environment as a sort of slow-release natural fertilizer.

Nowadays, the harvesting of peat moss is done mostly by large mechanized milling machines. They cover enormous acreage, vacuuming up scraped and dried peat moss to be packaged and sold for horticultural and agricultural uses. The largest producer of peat moss is Canada, with an estimated 626,200 square miles of peatlands, followed closely by Russia, with an estimated 579,000 square miles of peatlands. The United States, including Alaska, comes in third, with an estimated 115,800 square miles (Kivinen and Pakarinen 1981). Russia, with its vast acreage of peatlands, harvests most of its peat moss to feed boilers in electricity-generating plants.

True Bogs

Domed or raised bogs do not occur anywhere within the southern Great Lakes region. One would have to travel much farther north into Maine and Canada before encountering the many different types of raised bogs. Within the United States, raised bogs are known only from northeastern Maine, which is well north of our southern Great Lakes focus area. The most southeasterly of these Maine bogs is Big Heath, a 420-acre coastal raised peatland situated between Cadillac Mountain and the Atlantic Ocean within Acadia National Park. (There are at least 115 coastal raised bogs in Maine alone.) From there, coastal raised bogs can be found northward along the Atlantic coast into northern Canada. Although clearly a raised bog totally separated from any groundwater source, Big Heath and other raised bogs in North America are somewhat different in appearance from their counterparts in northern Europe; they are not as extensive in size or as dry as their European counterparts. Although floristically they share many of the same species of plants, there are some significant differences.

In general, raised bogs that receive water and nutrients strictly from atmospheric precipitation are the only true bogs as recognized by most peatland scientists. This includes any of the several different classifications known to occur in far northern latitudes in both Europe and North America. All other peatlands that are connected to and receive nourishment from groundwater or surface runoff water are collectively referred to by peatland ecologists as fens. Peatlands confined to basins and unable to expand upward beyond the regional groundwater levels that nourishes them are technically classified as poor fens or oligotrophic peatlands. The term *oligotrophic* comes from the Greek words *oligos,* meaning "poorly," and *trophe,* meaning "fed." Most of what we traditionally call bogs throughout the glaciated regions of the Midwest are

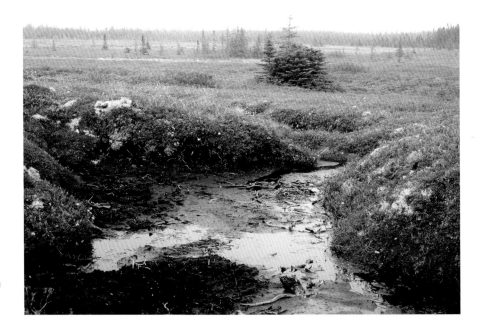

Big Heath is a famous raised or domed bog situated within Maine's Acadia National Park between Cadillac Mountain and the Atlantic Ocean. (Photo by Guy L. Denny.)

generally classified as poor fens or oligotrophic peatlands, they and are not considered true bogs in the strictest sense.

In contrast, highly nutrient-rich peatlands are called rich fens. They receive nourishment from flowing, mineral-rich groundwater in the form of underground springs or seeps flowing through limestone-rich gravels and/ or limestone bedrock. Rich fens are not restricted to basins but rather spread freely over mostly level ground from the source of their groundwater supply. These are calcareous, minerotrophic peatlands that are mineral-nourished or mineral-fed peatlands. They are also known as geogenous, earth-originating peatlands. Rich fens are very much a part of the peatland complexes occurring throughout the glaciated southern Great Lakes region and beyond.

Sphagnum Peat Moss

Let's first take an in-depth look at what we call our kettlehole sphagnum peat bogs. Because these ecosystems are primarily based on a blanket of sphagnum peat moss, let's take a closer look at *Sphagnum* mosses and how these plants have the ability to alter their environment. *Sphagnum* peat mosses are members of the genus *Sphagnum.* They are considered bryophytes, which is an informal group of nonvascular land plants consisting of the liverworts, hornworts, and mosses. *Sphagnum* mosses are the most abundant and essential floristic components of acidic peatland ecosystems. They are critical for the establishment

Sphagnum mosses have the ability to alter their environment. They are the most abundant and essential floristic component of acidic peatland ecosystems. If *Sphagnum* mosses die out, the entire sphagnum peatland ecosystem collapses. (Photo by Guy L. Denny.)

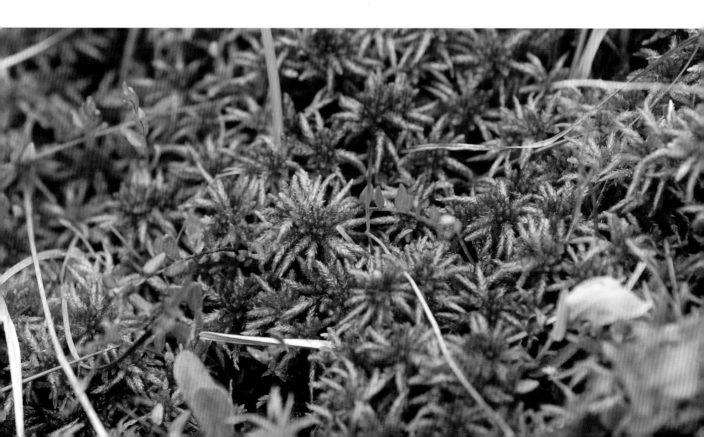

Fringed peat moss (*Sphagnum fimbriatum*). A close examination of blankets or clumps of *Sphagnum* moss reveals they are actually comprised of separate individual plants or stems, clustered in close proximity to neighboring individual stems. At the top of each stem is a leaf-compacted head or tuft of leaves called a capitulum. It is the capitulum, containing developing new branches, sexual organs, and a terminal bud, that continues to grow and extend the erect stem upward. (Photo by Guy L. Denny.)

and sustainability of such wetland ecosystems. If *Sphagnum* mosses die out, the entire sphagnum peatland ecosystem collapses.

There are an estimated 150 to 300-plus species of mosses worldwide in the genus *Sphagnum,* occurring in wetlands on every continent except Antarctica (McQueen 1990). The majority of species have a circumpolar distribution, with the greatest diversity of species occurring in North America, northern Europe, and Russia. These northern latitudes of the globe are known for having poor surface drainage associated with their glaciated landscape; long, extremely cold winters; and short, cool summers. Although precipitation is limited in these boreal and subarctic landscapes, climatic conditions, including high humidity levels, allow precipitation to exceed evaporation rates and plant biomass production to exceed decomposition, all of which favor peatland development and growth.

More locally, in the southern Great Lakes region, there are about 30 species or so of *Sphagnum* mosses. It can be somewhat challenging to identify peat mosses to their species, but fortunately many common species in the Great Lakes region are distinctive enough be fairly easily identified based on their form and structure (morphology) as well as where they are growing within the peatland. However, a few species can only be accurately identified using a microscope by someone knowledgeable with identifying the various species of *Sphagnum.*

Sphagnum mosses typically form cushions of plants. In many cases, extensive blankets of living *Sphagnum* are often referred to as sphagnum lawns or mats. A closer examination reveals that these clumps or blankets of *Sphagnum* mosses are actually comprised of separate individual plants or stems that are clustered in close proximity to neighboring individual stems. *Sphagnum* mosses

are rootless plants that grow from the top of their stems and die at the bottom, with the dead segments of the plants eventually decaying and accumulating to form peat. The lower stem ultimately is left behind, below water levels and the upper living peat mat, but it is still connected to the continually growing upper part of the stem. Deprived of sunlight, the lower part of the stem slowly dies and begins decomposing, which is the first step in the formation of peat.

At the top of each stem is a leaf-compacted head or tuft of leaves called a capitulum. It is the capitulum—containing developing new branches, sexual organs, and a terminal bud—which continues to grow and extend the erect stem upward, usually staying above water levels. Along the stem below the capitulum but above water levels are individual and somewhat inconspicuous stem leaves tightly pressed against the stem in addition to very conspicuous spirally arranged bundles or clusters (fascicles) of leaf-covered branches. Each fascicle of these very distinctive leaf-covered branches has either one or more pendant branches that droop downward along the main stem while the remaining branches consist of two or more branches distinctively spread outward from the main stem. Different species have different arrangements of these usually stout side branches and drooping pendant branches. Branch leaves differ significantly from stem leaves in size, shape, and structure, all of which are also useful in identifying *Sphagnum* mosses to species level.

The individual leaf cells, both stem and branch leaves of *Sphagnum,* are one-cell thick with two distinctly different types of cells. There are very large,

Blunt-leaved peat moss (*Sphagnum palustre*). *Sphagnum* mosses are rootless plants that only grow from the top of their stems and die at the bottom, with the dead bottom segments of the plants eventually decaying and accumulating to form peat. (Photo by Guy L. Denny.)

clear leaf cells and branch cells called hyaline cells that store large quantities of water, and there are very much smaller living chlorophyll cells among the hyaline cells that manufacture food and other chemical compounds. The ability to wick up and store large quantities of water is a very special feature of *Sphagnum*. Both the lower submersed dead portions of the plants as well as the living upper portions act like wicks pulling up water by means of capillary action. Put simply, *Sphagnum* moss acts like a sponge. One can grab a handful of living and recently dead strands of *Sphagnum* and wring out an amazing amount of water. After placing that handful of moss back in position on the bog mat, that handful of moss will then fill right back up with water. Some species of *Sphagnum* are known to hold 20 to 27 times their dry weight in water, depending on the species of *Sphagnum* (Crum 1991). This special feature enables them to grow above the water table as well as withstand bouts of dry weather that would otherwise dry them out. Because of this remarkable ability, dried sphagnum is more than twice as efficient in absorbing fluids as cotton. Native Americans used dried peat mosses as diapers, and during World War I, the Allies used dried *Sphagnum* as field surgical dressing—owning both to its absorptive abilities as well as to its natural sterility do to its acidity.

In addition to their amazing ability to wick up and store large quantities of water, *Sphagnum* mosses also have the ability to acidify their wetland environment. This is partially accomplished through a process called cation exchange. An ion is an electrically charged atom or atoms. When a neutral atom or molecular group of atoms loses one or more electrons during a chemical reaction, the loss of electrons results in a positively charged ion known as a cation. Among the chemical compounds manufactured by *Sphagnum* mosses is a compound called galacturonic acid, which plays the lead role in cation exchange. The galacturonic acid molecules that enable cation exchange in *Sphagnum* mosses are continually produced in the capitulum of the plant and are therefore a continual source of acidification of its environment. Galacturonic acid molecules are permanently located in, and tightly bonded to, the cell walls of *Sphagnum*. Galacturonic acid is what chemists call a long-chained carbon compound. Every sixth carbon component in this compound is part of what is known as a carboxyl acid group, -COOH. Carboxylic acids freely give up and release their hydrogen cations into the surrounding environment (McQueen 1990). As these hydrogen cations are released from *Sphagnum*, they are simultaneously replaced by cations of vital nutrients critical for plant growth extracted from the surrounding environment. These nutrients include potassium, calcium, magnesium, and sodium. Carboxyl acid will readily exchange its hydrogen cation for a metal cation of calcium (Ca.+), sodium (Na.+), and potassium (K.+) drawn out of the surrounding environment. These nutrients are removed from the environment and then strongly bound up in the peat moss, making them unavailable to other peatland plants. The released

concentration of hydrogen ions, in turn, acidify their surroundings. The more hydrogen cations released in solution, the more acidic the environment becomes. This combination of reducing nutrient availability and acidification of the peatland environment limits the diversity of plants that can survive in such a harsh, nutrient-poor setting. Even after *Sphagnum* dies and starts to form poorly decomposed peat known as fibric peat, it continues to release hydrogen cations into the surrounding environment through the galacturonic acid cation-ion exchange process, but this is to a lesser extent than when the *Sphagnum* was alive. Also, the decomposition of galacturonic acid bound to the cell walls of sphagnum peat further acidifies the environment as the cells start to decay during the peat-forming process.

Directly below the living layer of *Sphagnum* moss is the beginning of the peat layer. Because of waterlogging, peat is devoid of oxygen about 8 inches below the surface of the bog. The first peat layer near the bog surface is known as the fibric peat layer. The upper levels of fibric peat hold a great deal of water and some oxygen. More than two-thirds of plant matter in this layer of peat are recognizable pieces of plant material because there is so little decomposition that has at yet taken place. The next layer is known as hemic peat and is far more decayed with fewer recognizable plant fibers. The lowest and most decayed layer of peat is sapric peat, which is very dark in color, contains less than one-third plant fiber, and is comprised of lake sediments and well-decayed peat. While water can move through fibric peat, waterlogged hemic and sapric peat are impermeable to additional water movement and strongly retain water.

Organic sulfur compounds are held in plant cells. When these compounds are eventually freed by decay under anaerobic conditions deep in the layers of peat, hydrogen sulfide (with its rotten-egg smell), along with carbon dioxide, methane, and ammonia gases are released. Another name for methane (CH_4) is marsh gas. Often when one probes hemic and or sapric peat, gas bubbles of methane rise to the surface of the peat. Methane will readily ignite on contact with air. This can be easily and clearly demonstrated in the field by touching a flame to these bubbles of methane as they reach the surface of the bog.

Sphagnum mosses not only acidify the bog ecosystem through cation exchange, but even more significant, they also release large quantities of organic humic acids into the environment as peat decomposes. Humic substances, as they are called—including humic acids, fulvic acids, and a substance called humin—are formed during the process of partial decomposition of organic plant matter by anaerobic microbial organisms. In the case of peat, this involves the breakdown of lignin and cellulose from the cellular structure of sphagnum peat, releasing incredibly large amounts of these organic acids into the surrounding environment. Lignin is the substance that holds cellulose fibers together adding structural strength and stiffness to cell walls. Murky bog water is typically brown in color, owing to the presence of these water-soluble

humic substances. These humic substances are what causes the flesh and skin of European bog bodies to be tanned. Other factors, such as acid rainfall and acids as by-products of plant respiratory metabolism, also contribute to the acidification of peatlands. However, cation exchange and especially the release of humic substances appear to be the main factors responsible for peatland acidification; the latter is now believed to be the most significant factor.

Another environmental modifying feature of *Sphagnum* moss is its ability to create an insulating blanket of plant material. The hyaline cells of *Sphagnum* are large and empty and can hold amazing amounts of water. This, in concert with its unique leaf structure, serves as a very efficient blanket of insulation— a more efficient insulator than dry *Sphagnum*. Walking out onto a sphagnum lawn in midsummer can be like walking into a sauna bath, especially during the heat of the day when evapotranspiration can be at its highest. Yet, while surface temperatures can reach 100 degrees Fahrenheit or more, temperatures at root level may be no more than 60 degrees Fahrenheit or less. Not only does this water-saturated blanket of insulation keep subsurface temperatures cool, but it also holds atmospheric oxygen at bay. Water trapped in hyaline cells is not receptive to atmospheric oxygen. In fact, oxygen diffuses four times more slowly in water than in air and is retained poorly in stagnant kettlehole waters.

Limiting Factors in Kettlehole Peat Bogs

Sphagnum peatlands are inhospitable environments for plants that are unable to adapt and cope with harsh environmental conditions, including low-nutrient levels, high acidity, cold soil temperatures, and low oxygen or anaerobic conditions. Since *Sphagnum* moss is continually growing, other bog plants sharing the sphagnum lawn must keep from being overtopped and buried and must stay above the sphagnum blanket or risk being buried and cut off from sunlight.

Peatland ecologist have long noticed that many bog plants, especially low shrubs in the Heath Family (Ericaceae) growing on the open sphagnum mat, have adaptations similar to desert, arctic, and prairie plants that have to minimize loss of water through evapotranspiration (direct evaporation and that of transpiration from the surfaces of the plant). These adaptations include evergreen leaves often with leathery or waxy surface coatings, sunken and protected stomata (leaf-breathing pores), leaves that are curled under along their edges, and even some with a coatings of fine hairs, especially on their undersides.

In 1898, German scientist Andreas Schimper (1856–1901) in his book *Pflanzengeographie auf Physiologischer Grundlage,* later published in 1903 in English as *Plant Geography on a Physiological Basis,* theorized that bog plants, growing with access to abundant water, cannot access that water because of its acidity. So, in effect, they grow in physiological drought conditions. Therefore, they have developed adaptations to minimize loss of water or to decrease their need for it (Johnson 1985). This theory was accepted by scientists until about the mid-1960s, when laboratory experiments did not show a strong correlation between acidity and the ability of bog plants to take up water. Currently, the thinking is that these adaptations have more to do with nutrient deficiencies. What seems to have been overlooked is that at root level, temperatures are significantly lower for desert, prairie, and bog plants than surface temperatures

and that perhaps this also plays a role in these adaptations. Nutrient deficiencies in peat substrate are significant limiting factors, but several of these plants with these special adaptations address the lack of nutrient availability in other ways, such as through a remarkable symbiosis between their roots and soil fungi, termed mycorrhizae. Mycorrhizal associations occur in most members of the Heath Family, as well as in numerous other species of plants.

Mycorrhizal Associations

Mycorrhizal associations are symbiotic root/fungus associations that enable root hairs to be embraced by or penetrated by threadlike fungal hyphae (root-like structures) that are far more capable of absorbing nutrients than root hairs alone. The name comes from the Greek words *mykes,* meaning "fungus," and *rhiza,* meaning "a root." In mycorrhizae, the fungal hyphae colonize the host plant's root tissues, either intracellularly (endomycorrhizal or arbuscular mycorrhizal fungi that penetrate the cells), or extracellularly (ectomycorrhizal fungi that simply wrap around the outside of the cells). Hyphae are rootlike filaments of a fungus collectively known as mycelium. What we typically see

The fruiting caps of many mushroom species can be seen in sphagnum bogs. These are the aboveground, spore-producing bodies of the underground symbiotic root/fungus parts of these plants. (Photo by Gary Meszaros.)

as an aboveground mushroom is only the fruiting body of the fungus. Most of the plant is out of sight underground in the form of mycelia. Mycelia have a higher absorptive capacity for mineral nutrients and water, partially due to the larger surface area of hyphae, which are longer and finer than root hairs. The fungus shares the nutrients it absorbs with its host. The host, in turn, supplies the fungus with carbohydrates it manufactures through photosynthesis.

Cold Root Level as a Limiting Factor

Since a waterlogged blanket of living *Sphagnum* moss is such an excellent insulator, spring comes late for bog species. The insulating blanket of *Sphagnum* can keep temperatures at root level in a kettlehole peat bog significantly lower than surface temperatures well into summer. However, on cold days during the growing season, direct sunshine falling on the sphagnum mat, and warm drying winds blowing across a mat, pull water out of plants through evapotranspiration faster than cold roots can take it up. This situation is not at all unlike plants growing in a tallgrass prairie having adaptations to minimize loss of water from evapotranspiration. When subjected to scorching sun and drying winds at surface levels, underground roots 8 or more feet down are working hard to take up enough moisture from soil at depths where soil temperatures are much lower than surface temperatures. The rate of water uptake could not keep up with the rate of water loss aboveground were it not for special adaptations that prairie plants have for minimizing water loss aboveground.

Some research has demonstrated that at low root level temperatures, plants have some reduction in their ability to take up water from their surroundings, a problem that is exacerbated by significantly higher temperatures at aboveground level at the upper portions of plants being impacted by direct sunlight and warm drying winds. The reasons for this are that cold temperatures at root level retard root growth and, more importantly, root hair formation; alter the viscosity of protoplasm within cells, slowing down its flow; and decrease the membrane permeability of cell walls (Crum 1991). All of these play a role in slowing down the uptake of water, even in the case of a bog plants being rooted in waterlogged peat. That water is simply not readily available to them.

In the Midwest, during midsummer days, surface temperatures recorded on sphagnum mats frequently reach 95 degrees Fahrenheit and higher. Yet, as previously mentioned, temperatures at root level beneath the mat rarely exceed 60 degrees Fahrenheit and are often between 45 and 55 degrees Fahrenheit. That is a significant difference in temperatures. The differences between the evapotranspiration surface on the leaves of bog plants and the water-absorbing surface on their roots can be 10 to 50 degrees Fahrenheit (Crum 1991). Also, most peatland plants evolved to grow and flourish in cold northern latitudes

of the boreal forest region, where the colder climate and poorly drained topography is more conducive to peatland growth. In the boreal forest regions where summers are short and cooler and winters are extremely cold and long, it takes much longer for substrate temperatures to warm up, despite the fact that on any sunny day, surface temperatures can get quite warm. Pockets of ice can persist beneath the insulating *Sphagnum* moss blanket well into spring and even remain frozen longer in extreme northern latitudes.

Most kettlehole bogs are sunken depressions in the landscape frequently surrounded by much higher ground, making them cold-air sinks. Cold air is heavier than warm air so it tends to accumulate in lower spots on the landscape, such as kettlehole depressions especially at night after daytime heating. The long-term effect is that it takes a kettlehole bog longer to warm up than the surrounding landscape. Consequently, growing seasons can be shorter and colder for species of plants living in a low-lying kettlehole depression. This is a benefit for northern species adapted to shorter growing seasons.

Vegetative Composition and Transitions of Kettlehole Sphagnum Peat Bogs

We all recognize the global climate gradient from southern climates northward to northern climates; palm trees occur in southern Florida, spruce trees in Canada. Yet during the Pleistocene, species of plants and animals whose home range today extends no farther south than Canada were able to extend their range far southward in front of the glacial wall of ice. Of course, as the Pleistocene came to a close, temperatures warmed, and as the Wisconsinan Glacier melted northward, most boreal forest species retreated with the glacier to where cold, moist climate conditions favored such northern species. The returning warm climate of the Midwest favored more southern deciduous forest species at the expense of those boreal species that had been able to survive south of the Great Lakes region during the Pleistocene.

Boreal peatland species cannot survive in the warm climate of the Midwest except in places were special environmental conditions enable them to survive as living relics of the Ice Age. Some boreal species such as black spruce have long since disappeared from the more southerly landscapes of Ohio, Indiana, and Illinois. Still other boreal species are well into the process of disappearing from these states, including tamarack, Labrador tea (*Rhododendron groenlandicum*), and small cranberry (*Vaccinium oxycoccos*). Despite this general trend, other boreal species including leatherleaf (*Chamaedaphne calyculata*), large cranberry (*Vaccinium macrocarpon*), and northern pitcher plant (*Sarracenia purpurea*) seem largely to be holding their own. Those special places where boreal species still persist are the kettlehole sphagnum peat bogs and rich fens of the Midwest.

Since these bogs and fens are products of the Wisconsinan Glacier, and because the southernmost extent of the Wisconsinan Glacier occurred in Indiana and Ohio, we are going to first take a look at bogs and fens in glaciated Illinois,

Kettlehole Bog in Michigan is a typical North Country kettlehole sphagnum peat bog with an extensive, floating sphagnum lawn encroaching out over the open lake. The coniferous forest on the extreme outside of the bog is dominated by black spruce and northern tamarack trees. (Photo by Guy L. Denny.)

Indiana, and Ohio and then go northward to the upper Great Lakes northern states located within the Northern Deciduous/Conifer Forest ecoregion. Kettlehole bogs in Minnesota, Wisconsin, the Upper Peninsula of Michigan, and the Adirondacks region of New York look similar to kettlehole sphagnum bogs in the southern Great Lakes states, including the northern halves of Illinois, Indiana, and Ohio. However, these more northern states have additional boreal bog species present that have long since disappeared from, or have just about disappeared from, more southern situated kettlehole sphagnum peat bogs and rich fens

Although the Wisconsinan Glacier extended well south of central Ohio, the southernmost extant sphagnum peat bog in Ohio is just east of Columbus: Cranberry Bog State Nature Preserve. This preserve is a floating (rising and falling with water levels) bog island in Buckeye Lake in Licking County east of Columbus. Cranberry Bog is an anomaly in that it originated as a sphagnum peat bog that developed in a segment of a very deep pre-glacial river valley that had been cut off by glacial drift and naturally impounded. Over the next few thousand years, this "finger lake" filled with peat and silt and became a

large marsh with only a long but narrow sliver of open water remaining. In 1830, a dam was completed on the west end of this peatland complex, and the area was flooded to create a feeder lake to furnish water needed for a canal

Black spruce bogs or muskegs range across northern Canada, like this example in Canada's Algonquin Provincial Park. (Photo by Gary Meszaros.)

locks system for the Ohio & Erie Canal. Only the youngest and most buoyant segment of the bog mat survived the flooding. This originally 50-acre segment of bog mat stretched and rose 8 feet with the new water levels and survives today as a much smaller sphagnum bog mat island surrounded by the waters of Buckeye Lake.

Tamarack (*Larix laricina*) is one of only two species of deciduous trees native to eastern North America. In autumn, after the hardwoods have dropped their leaves, tamarack needles turn a beautiful golden-yellow before falling to the ground. (Photo by Guy L. Denny.)

Deep kettlehole lakes originating from Wisconsinan glaciation occur south of central Ohio, including Stages Pond State Nature Preserve located in Pickaway County just north of Circleville, Ohio, but they do not have any remnants of boreal peatland plants. Instead, they support typical shoreline and emergent wetland plants. Kettlehole lakes situated so far south have been free of glacial ice longer than kettlehole lakes elsewhere within Wisconsinan glaciation. Intact sphagnum kettlehole lakes, with the exception of Cranberry Island in Buckeye Lake, don't appear in Ohio until we get into the northern quarter of the state, where extensive outwash deposits occur in Wayne and Homes Counties in the vicinity of Shreve, Ohio. Not all of these kettlehole lakes support sphagnum bog mats, but those that do, such as Brown's Lake Bog State Nature Preserve owned by the Ohio Chapter of the Nature Conservancy, have a very nice assemblage of boreal bog species. However, there are no tamaracks that have been able to survive this far south. Tamarack was certainly present at some time in the past, but this far south, the trees now surrounding these kettlehole bogs are mostly red maple (*Acer rubrum*), silver maple (*A. saccharinum*), American elm (*Ulmus americana*), green ash (*Fraxinus pennsylvanica*), swamp white oak (*Quercus bicolor*), and pin oak (*Q. palustris*).

In Ohio, the very best, intact kettlehole sphagnum bog communities occur in northeastern Ohio, in very extensive hilly glacial outwash sand and gravel deposits situated between the Killbuck and Grand River lobes of the Wisconsinan Glacier. Most are located in the Canton/Akron corridor northeastward

Mud Lake Bog State Nature Preserve, situated in extreme northwestern Ohio, has a traditional floating sphagnum peat bog mat on one side of the kettle lake and a rich fen community on the opposite side of the lake. (Photo by Guy L. Denny.)

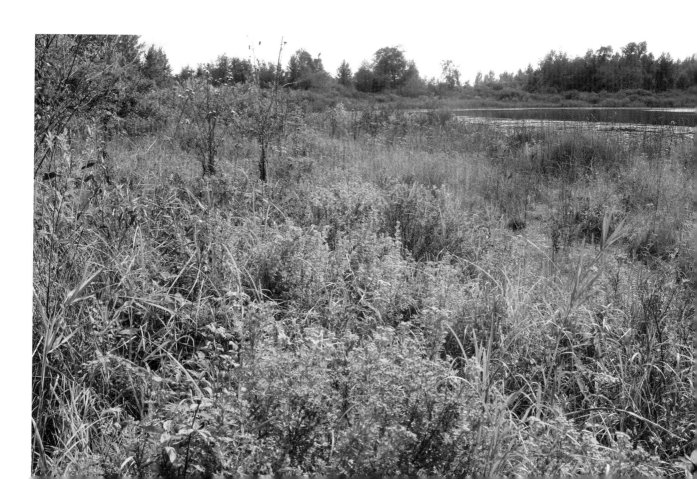

up into Geauga County. Here not only do we have a more diverse and complete assortment of boreal species represented in kettlehole sphagnum bog communities, but now we are far enough north to enable stands of surviving tamaracks to surround these kettlehole bog basins. Two of the very best such kettlehole sphagnum bogs open to the public with boardwalks are Triangle Lake Bog State Nature Preserve and Tom S. Cooperrider (Kent) Bog State Nature Preserve, both located in Portage County. Peatland communities also developed west of here in the till plains, usually within the shallow beds of proglacial lakes, but most of these peatlands were easily drained and converted to agriculture long ago. (The geologic term proglacial lake is used to identify glacial lakes created by meltwaters from melting glaciers during an ice age.) One does not encounter any surviving kettlehole bogs in this region of the state until one reaches the extreme corner of northwestern Ohio. The best of these is Mud Lake Bog State Nature Preserve in Williams County. Tamaracks surround the sphagnum bog mat. In this multistate area, where Michigan, Ohio, and Indiana all come together, there are a number of glacial landscape features that support kettlehole sphagnum peat bogs in all three states. Mud Lake is interesting in that it supports a sphagnum bog mat on one half and a rich fen community on the opposite side of the lake.

It is from about this latitude northward to about the southern half of Michigan that one starts to depart the mesic southern temporal forests and approach the Northern Deciduous/Conifer Forest region of the country. Once paper birch (*Betula papyrifera*), quaking aspen (*Populus tremuloides*), balsam fir (*Abies balsamea*), black spruce, white spruce (*Picea glauca*), white pine (*Pinus strobus*), red pine (*Pinus resinosa*), northern white-cedar, and tamarack become commonplace on the landscape, we enter the extreme southern boreal forest region of the Northern Hemisphere. From this point northward we are within the home range of most plants commonly found surviving in the more southern kettlehole sphagnum peat bogs and rich fens.

Natural Succession from Open Water Shoreward across the Sphagnum Mat

Present-day kettlehole lakes occurring in the southern Great Lakes region have survived primarily because they are too deep for peat to have completely filled them. This is a process called lake-fill. Shallower kettlehole depressions have long since filled with peat and then, through the process of natural succession (one plant community replacing another), peat bog has been replaced by swamp forest or even wet woodland communities.

Shortly after the glacial ice melted northward and the blocks of ice forming kettlehole depressions had melted, boreal species quickly colonized the

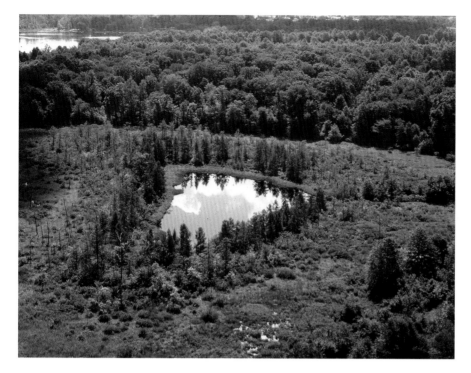

As we see here with Flat Iron Lake Bog in northeastern Ohio, kettlehole sphagnum peat bogs usually develop somewhat distinctive concentric zones of vegetation from open water to sphagnum lawn to a low shrub zone, followed by a tall shrub zone, then to a swamp-forest zone, and finally to a moat, known as a lagg, adjacent to the original shoreline of the kettlehole lake. (Photo by Guy L. Denny.)

shoreline of these deep kettlehole lakes. Because kettlehole lakes usually have no significant inflow or outflow, their anaerobic, deep, and cold waters become acidic as peat builds up. This process occurs because there is no significant flushing of water to remove the acids built up of humic materials that are generated from the partial decomposition of organic matter. The sources of water for kettlehole lakes are groundwater and surface runoff from adjacent higher ground. There are more nutrients made available in a kettlehole depression than in a raised bog whose only nutrient input comes from atmospheric moisture and windblown nutrients. Despite this, there are far less nutrients available in the water of a kettlehole sphagnum peat bog than are present in a rich fen fed by flowing mineral-enriched groundwater. Water retains oxygen poorly. Accordingly, the waters within kettlehole lakes can become quite anaerobic and very acidic.

Kettlehole sphagnum peat bogs usually develop somewhat distinctive concentric zones of vegetation from open water to sphagnum lawn, to a low shrub zone, followed by a tall shrub zone, then to a swamp forest zone, and finally to a moat known as a lagg, which is adjacent to the original shoreline of the kettlehole. Each zone makes the inevitable long-term transformation that ultimately transforms open bog lake into swamp forest. Species of *Sphagnum* moss and sedges most typically lead the way in this transformation. Kettlehole sphagnum peat bogs are generally similar in appearance, but no two are exactly alike, especially considering the influence that climatic gradients, south

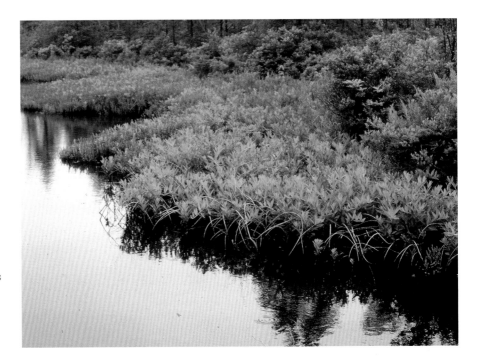

As the floating stems of swamp loosestrife arch out over a kettlehole lake like this one in Ohio, they form a protective network of small vegetative rafts that enable *Sphagnum* moss and other bog plants to become established. Thus, the process of building a floating bog mat begins. (Photo by Guy L. Denny.)

to north, have on the floristic composition of each. As living *Sphagnum* moss and peat become established around the shoreline, the lake-fill process begins with the very early stages of a sphagnum mat being developed. However, for rootless *Sphagnum* mosses to be able to grow out over open water and build up peat deposits, they need some kind of protective framework to support them from wind and wave action.

In shallow basins, sedges, especially wiregrass sedge (*Carex lasiocarpa*), often fill this role. However, in steep-sided deep kettlehole basins this task requires a species of plant that can be anchored to the shoreline yet send out rhizomes (underground stems) and roots over open water. In Ohio kettlehole sphagnum peat bogs, this task is often primarily the role of swamp loosestrife (*Decodon verticillatus*). In some kettle bogs in adjacent states and especially northward, low-growing bog shrubs, leatherleaf, and bog-rosemary (*Andromeda glaucophylla*) can also lead the way sometimes with swamp loosestrife.

Swamp loosestrife is not exclusively a boreal species. Rather, it ranges from Florida and Texas northward all the way to the boreal forest regions of Canada, growing in all kinds of wetlands, including bogs. Swamp loosestrife has the special ability to grow out over bodies of open water. Where the tips of its long arching outward stems come in contact with water, spongy, white, air-filled tissue called aerenchyma develops, causing the stem to swell several times its size, providing buoyancy and enabling that segment of the stem to float. Aerenchyma tissue also allows the passage of gases, including oxygen, between the parts of the plant that are above the waterline and its roots. A small, floating vegetative

mass is created from which new roots descend and new stems emerge. These new rooted stems continue sending out new arching stems that continually repeat the process, creating a protective network of arching stems extending out over open water. Where new stems come into contact with water, numerous small rafts are established at the base of the floating stems.

Each small sphagnum raft continues to grow in size and into vegetative hummocks. Each hummock continues to grow larger each year, until eventually it merges with neighboring hummocks to form the basis for what will become an extensive floating bog mat. (Photo by Guy L. Denny.)

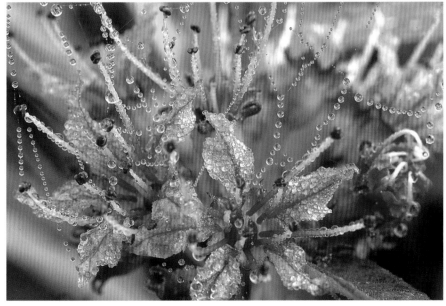

Swamp loosestrife (*Decodon verticillatus*) has the ability to grow out over water. Thanks to air-filled tissues and arching stems, it is able to float, creating a protective network. Its small pink blooms are attractive in midsummer. (Photo by Gary Meszaros.)

Within this protective network of stems paralleling the shoreline, and around each swamp loosestrife raft, a vegetative platform is created that enables *Sphagnum* mosses to become established and increase the size of the floating platform. As the base grows, it becomes suitable to accommodate the establishment of additional bog mat species including cranberries, sedges, and

As living sphagnum moss continues to expand over open water, it creates a network of roots and rhizomes and forms a floating blanket, or lawn, supporting a diversity of peatland plants. If one walks out on the sphagnum lawn, the ground seems to quake. This sphagnum lawn can be seen at Fern Lake Bog Nature Preserve in Ohio. (Photo by Gary Meszaros.)

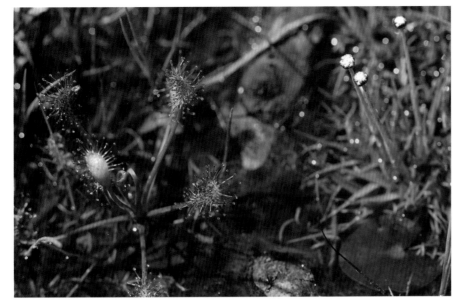

Spatulate-leaved sundew (*Drosera intermedia*) is more common in northern sphagnum lawns than in more southern occurring kettlehole bogs. It is state endangered in Ohio. Spatulate-leaved sundew occurs in the wettest places on the sphagnum bog mat, usually right along the edge of open water. (Photo by Guy L. Denny.)

ferns. In this way, small, floating hummocks of vegetation are established and begin to grow, accumulating peat as they grow in size. Each hummock continues to grow larger each year, until eventually it merges with neighboring hummocks to form the basis for what will become an extensive floating bog mat. The mat is comprised mostly of *Sphagnum* moss held together by the roots and rhizomes of numerous other bog species, especially low-growing woody species and sedges. As peat deposits build up, the floating bog mat becomes underlain with several layers of peat extending from the shoreline outward toward open water. Eventually the mat becomes solidly anchored to the shoreline. It takes thousands of years for the mat to grow outward and for sufficient peat to accumulate beneath the upper layer of *Sphagnum* held tightly together by a network of shallow, far-reaching intertwining roots and rhizomes. This floating peat mat can provide enough support to finally hold the weight of a person. As one walks on the mat, it quakes like a giant waterbed; hence the origin of the name quaking bog.

The extreme outer edge of the bog mat is usually too thin to safely support the weight of a person, but here we find some of the most interesting bog plants including round-leaved sundew (*Drosera rotundifolia*), spatulate-leaved sundew (*D. intermedia*), white beak-rush (*Rhynchospora alba*), small cranberry (*Vaccinium oxycoccos*), podgrass (*Scheuchzeria palustris*), marsh cinquefoil (*Comarum palustre*), bog yellow-eyed-grass (*Xyris difformis*), and bog buckbean (*Menyanthes trifoliata*). Both bog buckbean and marsh cinquefoil can extend their rhizomes well out over open water and sprout roots because their rhizomes also contain aerenchyma tissue just like swamp loosestrife. Farther back from this leading edge of the bog mat is a wide and thick blanket

Left: Podgrass (*Scheuchzeria palustris*) is not a grass at all but rather a member of its own family. It tends to thrive in the wettest areas of sphagnum lawn. It is a commonly encountered species northward but somewhat rare in bogs of the southern Great Lakes region. (Photo by Guy L. Denny.)

Right: Deep red flowers of the marsh cinquefoil (*Potentilla palustris*), a member of the Rose Family, can be found growing in wet meadows. (Photo by Gary Meszaros.)

comprised of several different species of *Sphagnum* mosses. This area of the bog mat, often referred to as a sphagnum lawn, is underlain by enough accumulated peat and a supporting structure of interwoven roots and rhizomes to become a firm, waterlogged yet anchored platform stretching well out over the kettlehole lake. The sphagnum lawn is a treasure trove of delightful bog species, including cranberries, carnivores plants, beautiful bog orchids, and cotton-grass. Here is a closer look at some of these more interesting species.

Cranberries

The prostrate woody vines of cranberries sprawl across the sphagnum lawn, forming dense stands. Two species of cranberries occur in North America, large cranberry (*Vaccinium macrocarpon*) and small cranberry (*Vaccinium oxycoccos*). The latter species is circumpolar in its global distribution and is more common in northern sphagnum peat bogs than it is in peat bogs in the southern Great Lakes region. As its name implies, small cranberry has smaller fruits that are not commercially harvested. It also has smaller and more pointed leaves than large cranberry. Small cranberry has a northern global distribution while large cranberry grows only in North America. Large cranberry, or at least cultivars of it, is the same species that is commercially grown and sold in grocery stores. One of the easiest ways to tell the difference between the two species of cranberries is when they are in flower or fruit. The flower stalks (peduncles) of small cranberry usually emerge from the tip of the stems rather than from along the stems, as with large cranberry that has the main stems usually extending well beyond the flowers or fruit. When the Pilgrims first settled along the Atlantic coast, it was the Native Americans who taught them the value of large cranberries as a food source. Reportedly, the Pilgrims

sent barrels of large cranberries back to Europe on their returning ships as the first crop exported from the New World.

There are two stories regarding how cranberry got its name. In both cases, the original name was "craneberry." The first account is that when the Pilgrims noticed wild cranes pecking for food in wild cranberry patches, they assumed, incorrectly, the birds were eating the berries—hence the name "berries of the

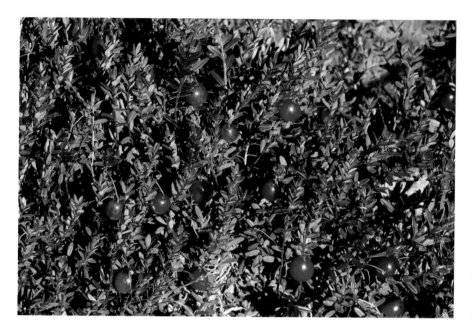

Left: In winter, leaves of large cranberries (*Vaccinium macrocarpon*) turn a deep red. Many varieties of this economically important plant are grown commercially. (Photo by Guy L. Denny.)

Below: Large cranberries (*Vaccinium macrocarpon*) are an important component of sphagnum bogs. Pilgrims were taught by Native Americans the value of cranberries as a food source. Small pink flowers appear in June. (Photo by Gary Meszaros.)

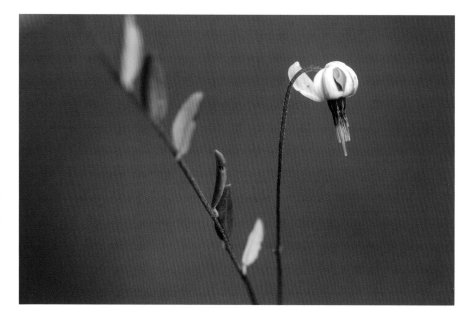

Small Cranberry (*Vaccinium oxycoccos*) is circumpolar in its global distribution and is more common in northern sphagnum peat bogs than it is in in kettlehole sphagnum peat bogs in the southern Great Lakes region. In Ohio, it is classified as state endangered. (Photo by Guy L. Denny.)

cranes," or "craneberries." The other account is the superficial resemblance of cranberry flowers to the head and neck of a crane. The single flowers with their strongly reflexed pink petals from which a long cluster of stamens emerge form a beak-like structure mounted at the tip of a long neck-like stalk, giving the appearance of the silhouette of a long-necked crane.

Small cranberry is an endangered species in the state of Ohio. This species is more common the farther north you go. It is well adapted for life in acidic, nutrient-poor, cold boreal peatlands. As a member of the Heath Family, cranberries, both large and small species, use mycorrhizae to help extract nutrients from peat that their roots alone cannot access. In winter, the leaves of cranberries turn dull red. This redness appears only in those cells exposed to light and is caused by anthocyanin leaf pigments. Anthocyanins are soluble glycoside pigments producing blue to red coloring in plants. This color change in late autumn is an adaptation that many evergreen alpine tundra plants exhibit, including small cranberry. Anthocyanins are capable of converting incident light rays into heat to warm plant tissues, an important adaptation in habitats where cold-hardiness is required for survival (Zwinger 1972).

Sundews (genus Drosera)

The spatulate-leaved sundew (*Drosera intermedia*) is more common in northern sphagnum lawns than in more southern kettlehole bogs. This sundew is endangered in the state of Ohio. The other species is the round-leaved sundew (*Drosera rotundifolia*), which is common in southern peatlands northward well into northern Canada. Both species are circumboreal in peatlands in North America and Eurasia. Of the approximately 135 species of sundews in

the world, most species also occur in southern latitudes, especially Australia and South Africa. Only spatulate-leaved and round-leaved sundews occur on sphagnum mats in the Northern Hemisphere. Two other species of sundews, linear-leaved (*D. linearis*) and *English sundew* (*D. anglica*), occur in rich fen ecosystems in the upper Great Lakes states and northward. The latter two species are calciphiles (plants that thrive in calcium-rich soils), which do

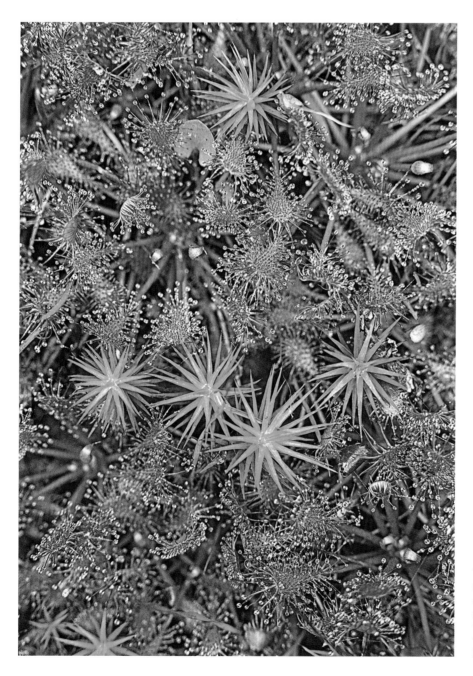

The flat pads of sundews (*Drosera rotundifolia*) are covered with reddish glandular sticky hairs that trap unwary insects like this hapless deerfly. (Photo by Gary Meszaros.)

not grow in acidic habitats. Spatulate-leaved sundew is found in the wettest places on the sphagnum bog mat, usually right along the edge of open water. Round-leaved sundew occurs more frequently on slightly drier sites among *Sphagnum* moss, often on hummocks of *Sphagnum* moss.

Although sundews are labeled carnivorous plants, the insectivorous plants would seem more accurate because they supplement their nutrient intake by attracting, capturing, and consuming insects. They accomplish this with fleshy leaves covered with glandular tentacles tipped with droplets of sticky secretions. The common name sundew is in reference to how the droplets of mucilage glisten in sunlight resembling morning dew. Likewise, the genus *Drosera* is Latin for "glistening in the sun." The sweet and very sticky substance topping the tips of the glandular tentacles attract and then entangle insect prey. The more the prey struggles, the more tentacles bend over to further entrap it. Slowly the tentacles force the prey downward to the surface of the leaf while at the same time the leaf slowly folds over the prey, putting it in closer contact to the surface of the leaf. On the surface of the leaf are glands that secrete digestive enzymes, ultimately digesting the prey and leaving only indigestible chitinous exoskeleton materials behind. The bending process that forces the prey downward might take anywhere from 3 to 20 minutes, depending on the size of the prey. Once the deed is accomplished, the leaf can open up and repeat the process a few more times before the leaf dies and is replaced. The roots of these two species of sundews are of themselves relatively useless except to anchor the plants and absorb water. Both species have mycorrhizal associations that allow their weakly developed roots to access some nutrients and water from the nutrient-poor peat substrate.

Northern Pitcher Plants

Of all the species of plants occurring on the sphagnum lawn, perhaps the most fascinating are northern pitcher plants. They are the most conspicuous and most botanically interesting carnivorous plants to adorn the sphagnum mat, often occurring in great numbers. Pitcher plants in the genus *Sarracenia* are confined to North America, where there are eight species with several subspecies, varieties, and forms. The genus *Sarracenia* honors Michel Sarrasin (1659–1734), a physician at the Court of Quebec who first sent a specimen to Europe for identification. The northern pitcher plant (*Sarracenia purpurea* subspecies *purpurea*) is the only pitcher plant native to boreal sphagnum peatlands. It is also the most widely distributed of all pitcher plants. The rest of the species of *Sarracenia* have more southerly distribution. Northern pitcher plants are well represented on sphagnum lawns in the southern Great Lakes region northward into Canada. Pitcher plants, as their name implies, have a basal rosette of colorful pitcher-like leaves incredibly well designed for attracting, trapping, and consuming insect prey. Pitcher plants do best in

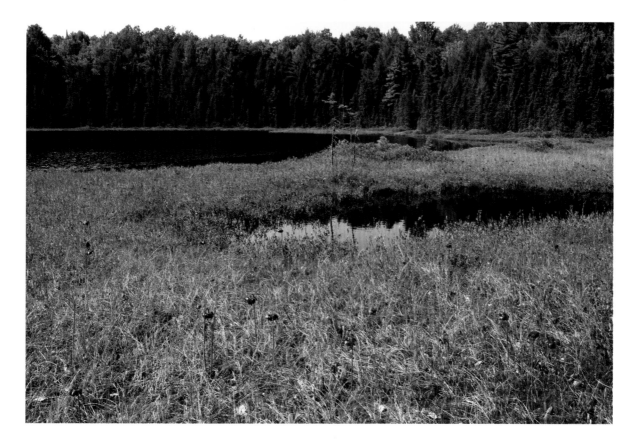

full sunshine, but they are highly shade tolerant and may be found growing under bog shrubs, albeit less robustly than those growing in open sunshine.

The basal leaves of pitcher plants are attached to a long rhizome. Each new growing season, old leaves slowly die back and are replaced by new leaves situated higher on the elongating vertical rhizome, keeping the basal rosette of leaves above from being buried by the fast-growing *Sphagnum* moss. The outer collar of each leaf has nectar glands that attract insect prey. Upon landing on the collar, prey, such as a wasp, hangs onto the collar while lapping up nectar, which, by some accounts, contains an intoxicant that seems to somewhat disorient victims. The leaf surface below the collar offers an ample supply of sweet nectar along with attractive red venation and hundreds of downward-pointing stiff bristles, directing the victim into the depths of the leaf. Slowly, and somewhat reluctantly, the prey gives up its foothold on the rim of the leaf collar and makes its way downward, feeding on nectar as it descends. Just below the bristle zone of the leaf is a second, very smooth, slippery zone where the prey loses its footing. The downward-pointing bristles seem to make it difficult for the prey to reverse direction back up the leaf and out to safety. Under high magnification of a microscope, this slippery zone is comprised of special cells laid down, one over the other, like shingles on a roof. These cells

Hundreds and hundreds of northern pitcher plants can occupy the sphagnum peat lawn of a kettlehole sphagnum peat bog like this cranberry bog in the Upper Peninsula of Michigan. (Photo by Guy L. Denny.)

are both sticky and easily dislodged. As the victim frantically struggles to keep from sliding farther down this smooth, vertical wall, cells break off and adhere to its feet and body, further weighing it down and accelerating its plunge into

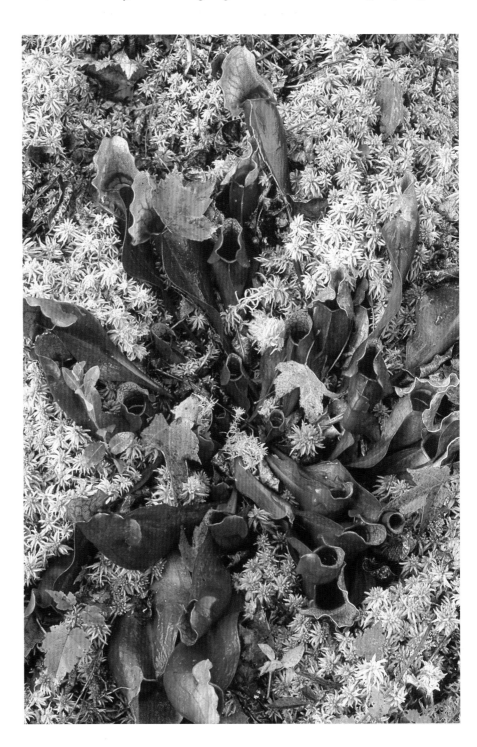

The pitcher plant's (*Sarracenia purpurea*) pitcher-like leaves make this fascinating plant unmistakable even in autumn. (Photo by Gary Meszaros.)

the liquid contents of the pitcher-like leaf. The liquid contents are comprised of rainwater, a wetting agent, bacteria, and digestive enzymes. The prey drowns and sinks to the bottom of the pitcher, where it is further digested and its nutrients are then absorbed into the plant. Pitcher plants are green chlorophyll-producing plants that don't need to rely on carnivores for nutrients. However, additional nutrients absorbed through carnivory greatly aid in plant growth and seed production. The same is true for all carnivorous plants, including sundews.

Pitcher plant flowers are intricately evolved to guarantee outcrossing with neighboring pitcher plants. Although many flowers have the ability to be pollinated with their own pollen, being pollinated by a neighboring plant increases genetic diversity. In late spring, pollinators, including bumble bees, are attracted by the fragrance and purple-red petals of northern pitcher plants. Each downward-drooping flower is mounted at the end of a long scape (single-flower stem). The stigmatic structure looks like an inverted umbrella with five points, each tipped with a tiny projected stigma. The drooping petals drop below and then flop over the edge of the umbrella-like structure. This structure prevents the petals from being pushed inward while allowing them to easily be pushed outward. As the bee tries to access the ample supply of pollen and nectar provided inside and beyond the petals, it finds the only way in is to slide through a slit between any two petals. In doing so, the bee must rub its back against one of the five stigma tips adjacent to the opening. This results in the bee rubbing off pollen collected from previously visited neighboring pitcher plants. Consequently, the plant it is visiting gets cross-pollinated from neighboring plants. As the bee successfully gathers nectar from within, pollen from the stamens of that plant rains down on its body. When it is ready to exit the flower, if it leaves by the same way it entered, the bee would simply self-pollinate that flower, defeating the purpose of cross-pollinating. However, this doesn't

The inside of a pitcher plant's red and green flaring lips is covered with downward-pointing bristles that help trap insects. (Photo by Gary Meszaros.)

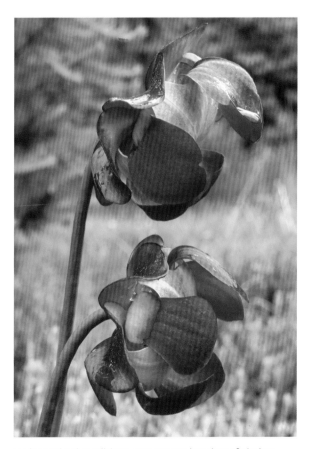

Under optimal conditions, one can see bunches of pitcher plants (*Sarracenia purpurea*), whose flowers are seen here. (Photo by Gary Meszaros.)

occur because the bee quickly discovers that it can make a fast and easy exit by simply pushing outward against any one of the five petals, thus avoiding that plant's stigmatic tips. It is really quite an amazing floral design to guarantee cross-pollination.

Bog Orchids

The most colorful and dainty gems of the sphagnum lawn are the orchids that make an appearance in early summer. All orchids depend on special mycorrhizal associations to extract nutrients from the nutrient-poor—especially nitrogen-deficient—environments in which they live. One of the most common and abundant bog orchid is the grass-pink or Calopogon orchid (*Calopogon tuberosus*) with its usually pink to magenta flowers. Both sepals and petals are the same color. Grass-pink orchids have a wide distribution and occur in a variety of habitats, including sphagnum bogs and rich fens throughout much of North America and eastern Canada. They do very well

Left: Large numbers of rose pogonias (*Pogonia ophioglossoides*) can sometimes be found in sphagnum bogs. (Photo by Gary Meszaros.)

Right: The rose pogonia's (*Pogonia ophioglossoides*) pink color and fringe-crested lip are distinctive. (Photo by Gary Meszaros.)

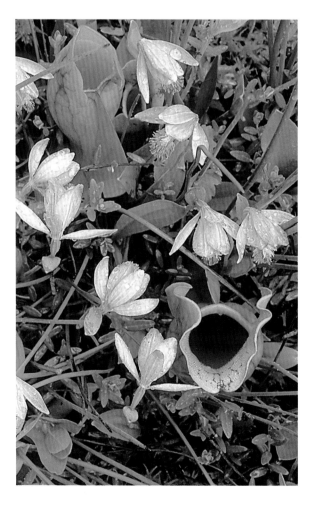
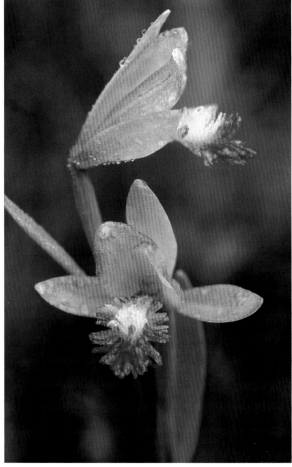

in sphagnum bogs, where they often can be quite abundant. Orchids tend to have three petals. Of these three petals, the labellum is the lowermost petal. It can form a pouch as we see with lady's-slipper orchids, or a lip as with the grass-pink orchid. Grass-pink is different from most other orchids in that the lip (labellum) projects straight upward and is the uppermost petal rather than the lowermost. It has an upside-down or reversed petal arrangement than what occurs in most orchids. Toward the top of the labellum there is a tuft of colorful yellowish hairlike filaments that have the appearance of stamens, seemingly offering nectar and pollen to a would-be pollinator, which is often a bumble bee or carpenter bee.

The name *Calopogon* derives from two Greek words, *kalos,* meaning "beautiful," and *pogon,* meaning "beard"—in reference to the beard or tuft of colorful hairlike filaments situated on the labellum. However, grass-pink orchids do not have any nectar or usable pollen available to pollinators, and they only apparently mimic those flowers that do provide nectar. Grass-pinks deceive pollinators into cross-pollinating these lovely orchids without providing any reward for their efforts. When the bee, attracted to the tuft of hairlike filaments, lands on the labellum, its weight causes the lip, which is hinged at its base, to fold forward, dropping the pollinator rather unceremoniously on its back squarely onto the spoon-shaped cradle of what is called the column. This is where the male (staminate) and female (pistillate) parts of the orchid are located. The yellow pollen sacks, called pollinia (sacks of pollen unusable by a pollinator), are located at the front on each side of the column. Pollinia become attached to the bristles on the bee's back, while at the same time, pollinia collected from neighboring grass-pink orchids are deposited on the stigma, completing the process of cross-pollination.

Perhaps the second most abundant species of orchid found growing on the sphagnum mat as well as in rich fens, often in association with grass-pink orchids, is rose pogonia (*Pogonia ophioglossoides*). It, too, has a wide distribution in North America and eastern Canada. Another common name for this orchid is the snake-mouth orchid. The specific epithet or species name, *ophioglossoides,* comes from the Greek words *orphis,* meaning "snake," and *glossa,* meaning "tongue." The Greek word *eidos* means "like or resembling." The name is in reference to the leaf of the adder's tongue fern whose leaf somewhat resembles the leaf of this orchid.

Rose pogonia has a single rose- or pink-colored flower comprised of three sepals and three petals, all of which are the same color. Blooming usually occurs in late June around the same time as blooming for the grass-pink orchid. The lower lip or labellum of rose pogonia is pink-fringed, with fleshy beard-like filaments striped with dark pink, purple, white, and yellow, designed to attract pollinators, which are mostly bumblebees. Unlike the grass-pink orchid, rose pogonia rewards its pollinators with small amounts of nectar.

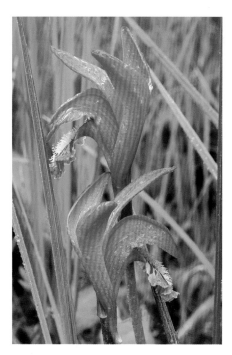 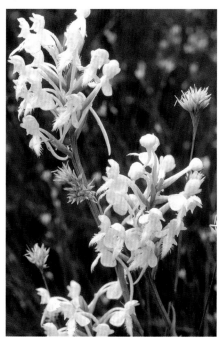

Left: Clusters of *Arethusa* orchids (*Arethusa bulbosa*) grow on a hummock in Maine's Big Heath, a classic example of a northeastern Atlantic coastal raised bog. (Photo by Gary Meszaros.)

Right: White-fringed orchids (*Platanthera blephariglottis*) bloom in bog clubmoss at Titus Bog, a white pine bog in western Pennsylvania. (Photo by Gary Meszaros.)

The third orchid encountered on sphagnum lawns, often in association with grass-pink and rose pogonia orchids, is dragon's mouth orchid (*Arethusa bulbosa*), which blooms just a little earlier than the other two. It is the only species in the genus *Arethusa*. Its scientific name is in honor of the beautiful, mythical Greek goddess Arethusa. This is a very rare species throughout its range, where it is mostly a boreal species restricted to semi-open sphagnum mats and hummocks. It requires partial shade. Dragon's mouth orchid has been extirpated (locally extinct) from Indiana, is known from just one location in northern Ohio where it is just hanging on, is threatened in New York, and is endangered in Pennsylvania. However, their populations are in better shape within the boreal forest regions of North America and Canada. Dragon's mouth orchid is one of the most beautiful of peatland orchids. It typically has a single pink terminal flower mounted on a somewhat bare stem. The lip or labellum is pink and marked with magenta spots with a crest of yellow bristles extending down the center of the petal. These showy markings and the fragrance of the flower are designed to entice pollinators, but *Arethusa* also offers little or no nectar. As pollinators exit the flower, they inadvertently pick up pollinia and carry it to the next flower, completing cross-pollination.

The last native orchid that might be encountered growing on the open sphagnum mat or lawn of a bog is the white-fringed orchid (*Plathanthera blephariglottis*). This, too, is a rare, mostly boreal orchid. It is very rare in Illinois and reportedly has been extirpated from Indiana, Ohio, and possibly Pennsylvania. It is a strikingly beautiful larger orchid with multiple white-fringed flowers on

a stem that grows about 1 to 1½ feet tall. This orchid can only be pollinated by pollinators with a long proboscis, such as sphinx moths, that are able to reach deep into the flower for nectar. The genus name *Plathanthera* comes from the Greek words *platys,* meaning "wide or broad," and *anthera,* meaning "anther." This is a reference to the broad anthers (male part of the flower that produces pollen) so characteristic of orchids in this genus. The species name *blephariglottis* comes from the Greek words *blepharis,* meaning "eyelash," and *glottis,* meaning "tongue," in reference to the tongue-shaped, heavily fringed lip of the flowers.

Few-seeded sedge (*Carex oligosperma*) is typically a sedge mat species of kettlehole sphagnum peat bogs. (Photo by Guy L. Denny.)

Sedges

There are a number of sedges that occupy the open sphagnum lawn. Sedges belong to a large family of plants, the Cyperaceae. Sedges somewhat resemble grasses, but most have triangular, solid stems and have very different flower and seed structures. Most species, such as few-seeded sedge (*Carex oligosperma*), wiregrass sedge (*C. lasiocarpa*), muck sedge (*C. limosa*), and three-seeded sedge (*C. trisperma*), typically encountered growing on the sphagnum mat might be somewhat challenging to identify for a beginning botanist. However, even the most inexperienced nature lover can easily recognize those sedges in the genus *Eriophorum,* commonly known as cotton-grass. In spite of their common name, cotton-grasses are not grasses but rather sedges particularly abundant in the arctic tundra regions in the Northern Hemisphere.

The generic name comes from two Greek words, *erion,* meaning "cotton or wool," and *phoros,* meaning "bearing." As their common name implies, these sedges have a very conspicuous, large tuft or tufts of cotton-like bristles sitting on top of their grasslike stems.

There are about 25 species of cotton-grasses worldwide, 11 of which are found in North America. During the Wisconsinan glaciation, these species occurred much farther south, but like most boreal peatland plants, they receded northward with the melting glacier. Perhaps the most common and abundant species still remaining in the southern Great Lakes northern states is tawny cotton-grass (*Eriophorum virginicum*), a common resident of sphagnum mats as far south as central glaciated Ohio. There is an old record for slender cotton grass (*E. gracile*) from Ohio, but it no longer occurs in the state. It doesn't occur in Indiana anymore and is very rare in both Pennsylvania and Illinois. One has to go well north of Ohio before slender cotton-grass and other sphagnum moss–loving species of cotton-grass can be found, including tussock cotton-grass (*E. vaginatum*) and rough cotton-grass (*E. tenellum*). Unlike the other species of cotton-grass that flower in spring, tawny cotton-grass flowers later in the year. In the late summer into autumn, the cotton ball–like tawny bristles become nearly pure white, adorning the sphagnum lawn with quite a showy display.

Sphagnum Mosses of the Peat Lawn

At first encounter, the sphagnum lawn appears like one solid or homogenous blanket of *Sphagnum* moss. Yet, upon closer inspection, we quickly see the green mass is comprised of many different species of Sphagnum in addition to some less abundant and less conspicuous species of other mosses. Those different species of *Sphagnum* do not occur randomly on the mat, but rather they depend on the particular requirements of each species in terms of its preference for nutrients, pH, and moisture levels as well as sunlight availability. There is no "one size fits all" when it comes to growth requirements for the various species of *Sphagnum* moss. Although oligotrophic kettlehole bog mats are often

referred to as level bogs, as opposed to ombrotrophic raised or domed bogs, a sphagnum lawn is anything but flat. Except for the very youngest parts of the mat closest to open water, it is a floral-scape of sphagnum hummocks and hollows. Longleaf peat moss (*Sphagnum cuspidatum*) occurs in the wettest, least acidic portions of the mat, often submerged in water at the very edge of the mat or in the wet hollows close to or at water levels at the base of sphagnum hummocks. This is one of the most aquatic species of *Sphagnum* mosses. Submerged as it often is, the long branches are reminiscent of wet fur. Numerous other species grow throughout the sphagnum lawn based on their specific needs. Some species form low hummocks supported by dwarfed leatherleaf stems. Finally, at the other end of the wet to dry gradient, tawny peat moss (*S. fuscum*) occupies the driest and most acidic area of the bog, which is at the

Left: Longleaf peat moss (*Sphagnum cuspidatum*) occurs in the wettest, least acidic portions of the bog mat, often submerged in water. Submerged as it often is, the long, thin branches have the appearance of green, wet fur. (Photo by Guy L. Denny.)

Below left: Tawny peat moss (*Sphagnum fuscum*) occupies the driest and most acidic area of the bog, which is at the tops of the largest and tallest sphagnum hummocks occupying the sphagnum mat. (Photo by Guy L. Denny.)

Below right: Except for the very youngest parts of the sphagnum mat closest to open water, the mat is a floral-scape of sphagnum hummocks and hollows. (Photo by Guy L. Denny.)

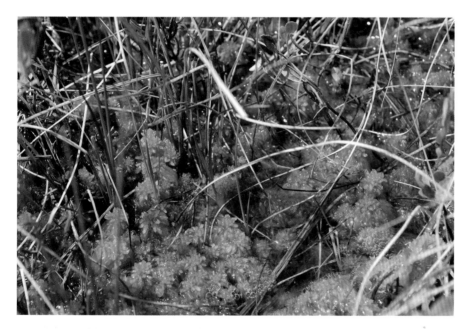

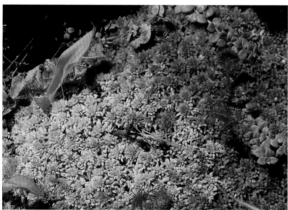

tops of the largest and tallest hummocks. It is easily recognized by its brownish color, small size, and tightly crowded growth form capping the hummock. The larger sphagnum hummocks typically develop around and over stunted shrubs or, in more northern latitudes, around isolated stunted trees trying to invading the peat mat, such as tamarack, black spruce, and white pine.

Low-Growing Shrub Zone

Farther back from the open water toward the original shoreline of the kettlehole basin, peat deposits have been building up for thousands of years beneath the floating mat. Closer to the shoreline, these deposits extend all the way down to the bottom of the basin, thus anchoring, and giving more support to, this zone of the mat than that occurring under the younger floating zone. Here, it is firm enough for the low-growing shrub zone to become established. Both leatherleaf and bog-rosemary play a role in growing out over open water and providing the protective root structure that enables the sphagnum mat to expand over open water across the kettlehole basin. At the very edge of the open water, these low-growing shrubs display vigor in their growth form as their wide, sprawling horizontal rhizomes and roots strengthen the bog mat. However, as they are overrun and overtopped by the ever-forward-advancing sphagnum mat, they tend to lose that vigor while being engulfed and buried by the blanket of advancing *Sphagnum*. Not until sufficient peat accumulates in the depths of the basin builds upward and outward to form a thick enough layer beneath them do these low-growing shrubs once again regain their vigor and take a foothold. Where there is a sufficiently thick layer of peat at root level to better support shrub growth, the low-growing shrub zone is finally encountered.

In more southern kettlehole peat bogs found in Illinois, Indiana, and Ohio, the sphagnum mats tend to be narrower and often situated mostly on the downwind side of a kettlehole lake and much smaller than the mats of kettlehole bogs situated farther north. Here, the shrub zone is well defined, more compact, and comprised of fewer species than those bogs occurring in more northern latitudes. The main components of the low-growing shrub zone are all ericaceous shrubs, members of the Heath Family. They include leatherleaf, bog-rosemary, Labrador tea (*Rhododendron groenlandicum*), and bog laurel (*Kalmia polifolia*). All depend on mycorrhizal associations to help them absorb nitrogen and phosphorus from the nutrient-poor peat in which they grow. All of these shrubs have evergreen leaves as well, giving them the advantage of being able to photosynthesize later into fall than those plants that drop their leaves and then begin photosynthesis earlier in spring while other plants are using up energy by replacing the leaves they dropped in autumn. Evergreen

leaves conserve energy that other deciduous plants are required to use in the annual renewal of leaves (Crum 1991).

In addition to evergreen leaves, these ericaceous shrubs tend to have thick, leathery leaves with protective coatings and in-rolled edges and wooly coatings on the underside of their leaves, all typical adaptations to minimize loss of water through evapotranspiration. There are two lines of thoughts among peatland ecologists; one is that these evergreen adaptations of shrubs are designed to conserve nutrients, and the other is that these leaf structural adaptations are designed to minimize loss of water. Both lines of thought certainly seem logical for plants that have evolved to survive in the northern circumpolar region of the world—and not just in waterlogged peat but also on very dry upland sites outside of peatlands in the more boreal forest regions of their range. Here are some of the most typical low-growing peatland shrubs.

Leatherleaf

Leatherleaf is a circumboreal species with an expansive global range, including all of Canada and Alaska extending through northern Eurasia. It is perhaps the most frequent and most abundant low-growing peatland shrub throughout its range. Amazingly, it does as well growing in sphagnum bogs in northern Ohio as it does in subarctic peatlands. Its associates, bog-rosemary and Labrador-tea, which are also circumboreal species, are now presumed extirpated from Ohio

Growing to 4 feet, leather-leaf (*Chamaedaphne calyculata*), an evergreen heath, forms large tangles at the edges of swamps and boggy meadows. (Photo by Gary Meszaros.)

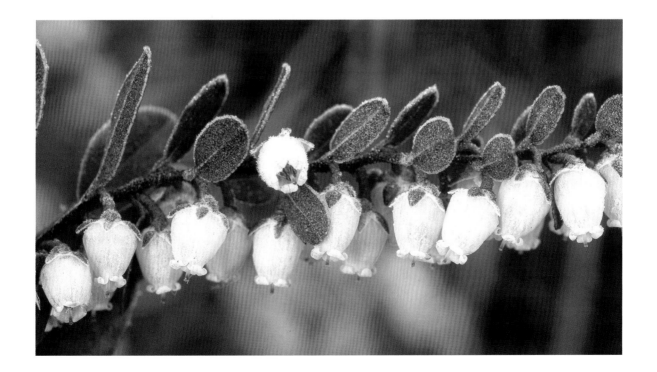

while leatherleaf is still flourishing forming large, spreading clonal colonies within numerous kettlehole basins. The urn-shaped white flowers of the leatherleaf appear in very early spring, occasionally even while ice is still present. The generic name, *Chamaedaphne,* comes from two Greek words, *chamai,* meaning "on the ground," and *daphne,* meaning "laurel." The specific epithet *calyculata* is Latin for "with an outer calyx." Leatherleaf is recognized as the universal low-growing peatland shrub. Notice how the leaves of leatherleaf are characteristically reduced in size on the flowering ends of its branches.

Bog-rosemary

Bog-rosemary (*Andromeda glaucophylla*), like leatherleaf, is also a circumboreal species with an extraordinary extensive global range. However, bog-rosemary is disappearing from the southern part of its range despite doing well in states north of Ohio and into Canada. It has been extirpated from Ohio and is rare in Illinois, Indiana, and Pennsylvania. It is very rare and local in southeastern Michigan but doing fine in the boreal forest regions of the northern half of the state (Voss 2012). Its common name comes from the superficial resemblance of its leaves to those of the seasoning herb. The cooking herb rosemary is in the Mint Family (Lamiaceae) and is not even closely related. The generic name *Andromeda* was given to this low-growing bog shrub by the famous Swedish botanist Carl Linnaeus (1707–1778) in honor of Andromeda of Greek mythology. In the mid-1700s, Linnaeus developed the Latin binomial system used to scientifically name plants and animals by genus and species. The specific epithet, *glaucophylla,* is Latin for "with blue-green leaves." Bog-rosemary's conspicuous, narrow, pale blue-green leaves definitely make it stand out from surrounding vegetation and easy to identify.

Labrador tea

Here is another low-growing bog shrub with an extensive circumboreal range throughout the Northern Hemisphere. However, just like bog-rosemary, Labrador tea is now considered extirpated from Illinois, Indiana, and Ohio and is rare in Pennsylvania. Farther north it is one of the most common low-growing shrub characteristic of peatlands in the boreal forest zone. This species was formerly known as *Ledium groenlandicum* and only recently was the scientific name changed to *Rhododendron groenlandicum.* The specific epithet *groenlandicum* means "of Greenland," where it is quite common. This species also occurs in every province and territory in Canada.

In May and early June, rounded clusters of attractive tiny, fragrant, sticky, white flowers of Labrador tea make an appearance at the terminal end of the branch stems. But the easiest way to identify Labrador tea is from its clusters of thick, oblong, slightly wrinkled, dark-green evergreen leaves with their conspicuously curled under edges. Its most distinguishing features are the

Facing page: Labrador tea (*Rhododendron groenlandicum*) blankets a Michigan wetland. This member of the Heath Family reaches the southern edge of its range in the upper Midwest. (Photo by Gary Meszaros.)

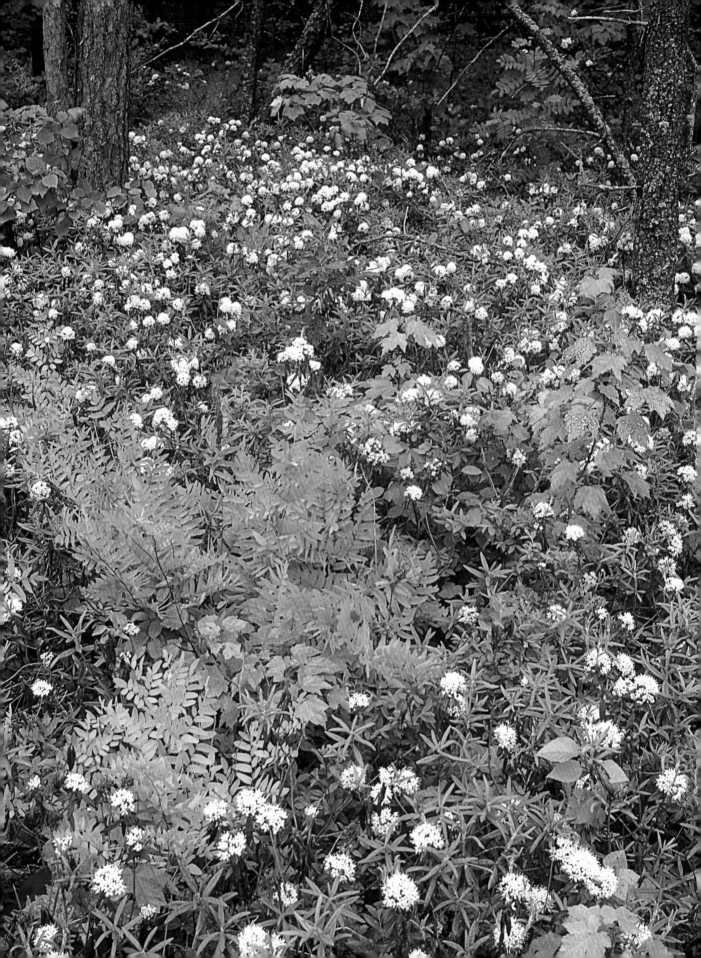

underside of the leaves that are conspicuously wooly, being white the first year and turning a rusty orange-brown in the second year. The leaves are very pleasingly strongly aromatic when crushed.

As the common name implies, leaves of Labrador tea have been used for countless centuries to make a fragrant herbal tea. Many Native American tribes from Canada south to the northern Great Lakes region used this tea as a refreshing drink as well as a medicine to treat a number of ailments, including asthma, colds, fevers, rheumatism, headaches, stomachaches, and burns (Gunther 1973; Smith 1933; Hedrick 1933). Early European explorers learned of the virtues of Labrador tea from the natives, and these newcomers called it Indian plant tea. It also became known as Hudson Bay tea in Canada, where it once was a major plant of commerce. However, tea made from the leaves or flowers of Labrador tea should never be consumed in excess. The tea is said to be toxic in concentrated doses because this shrub contains alkaloids known to poison livestock.

Bog Laurel

Certainly, thousands of years ago when the Wisconsinan Glacier was just north of the southern Great Lakes region, bog laurel (*Kalmia polifolia*) was well established on developing peatlands south of the Great Lakes region along with a number of other boreal species that have since disappeared or are slowly disappearing. Although bog laurel is not reported from Illinois, Indiana, or Ohio, and is rare in Pennsylvania, it still is a common low-growing bog shrub in the northern Great Lakes region stretching all the way north to Labrador and Alaska. It occurs in every Canadian province except British Columbia. The genus *Kalmia* honors one of Linnaeus's most accomplished students, Peter Kalm (1716–1779), who was sent to North America between 1747 and 1749 to collect new species of plants. One of those new species collected was mountain laurel (*Kalmia latifolia*), which was a species Linnaeus specially selected to honor his student. The species name *polifolia* comes from the Greek *polis*, meaning "gray or hoary," and the Latin *folium*, meaning "a leaf."

All members of the genus *Kalmia* are easily recognized by their unusual flowers. The five petals are fused together, forming a shallow saucerlike structure in which there are 10 pocket-like indentations lining the wall. As the flower matures, the developing stamens have their pollen-bearing anther heads thrusted into each of the 10 pockets opposite them. By the time the flower is fully open, the anthers are held under springlike tension within each pocket until a large pollinator, such as a bumblebee, lands on the flower, triggering the release of the stamens, which then shower the bee with pollen. As the bee flies off and lands on the next laurel flower, it inadvertently rubs some of this pollen off onto the receptive stigma located in the center of that flower, completing cross-pollination.

Toxic resinous glycoside substances called andromedotoxins, also known as grayanotoxins and acetylandromedol, occur in the flowers, leaves, twigs, and stems of most *ericaceous* shrubs. Only a few, such as those in the genera *Rhododendron* and *Kalmia,* contain levels of andromedotoxin significant enough to be lethal to livestock and humans if ingested. The biggest threat to humans is consuming honey or drinking herbal tea made from these plants. Bog laurel is highly toxic yet not as poisonous as its lookalike, and close relative, sheep laurel (*Kalmia angustifolia*), which is also known as lambkill for good reason. Both of these boreal species occur in sphagnum bogs, but while bog laurel is largely confined to peatlands, sheep laurel often grows in a wide variety of dry upland habitats, frequently in dense clusters or thickets. Although they look similar, the location of their rose-pink flowers on the stem distinguishes them. Bog laurel is smaller, with its flowers terminally clustered at the end of its current year's branches. The flowers of sheep laurel occur along the stem but beneath the leafy growth, not at the end of its branches.

Low-Growing Shrub/Tall Shrub Transition Zone

The low-growing shrub zone marks the line between the floating sphagnum lawn area of the bog mat that quakes when walked on and the more grounded peat and therefore firmer, and somewhat drier, bog mat. From this point on into the transition zone, the grounded bog mat of *Sphagnum* continues to become slightly drier and firmer, as the original shoreline of the kettlehole

 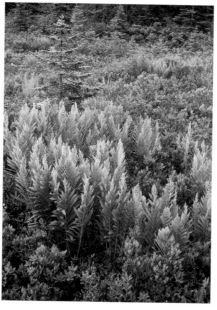

Left: The knee-high interrupted fern (*Osmunda claytoniana*) is one of the more common ferns growing within the low-growing shrub/tall shrub transition zone. The common name originates from the conspicuous interruptions in the center of the fronds by fertile spore-bearing pinnae. (Photo by Guy L. Denny.)

Right: The stiff erect stems of chain ferns (*Anchistea virginica*) are common in sphagnum peat bogs. The name chain fern refers to the chain-like sori or clusters of spores found on the underside of the fronds. (Photo by Gary Meszaros.)

Fiddleheads of cinnamon ferns (*Osmundastrum cinnamomeum*) begin to unfurl in May. (Photo by Gary Meszaros.)

lake basin is approached. Individual clumps of ferns can occur sporadically throughout the bog mat, but between the low shrub zone and the tall shrub zone they occur in the greatest numbers where they do well in both open sunlight and partial shade. The most common species of ferns growing within this transition zones between the low-growing shrub zone, the tall shrub zone, and into the peatland conifer tree zone are Virginia chain fern (*Anchistea virginica*), marsh fern (*Thelypteris palustris*), cinnamon fern (*Osmundastrum cinnamomeum*), interrupted fern (*Osmunda claytoniana*), and royal fern (*Osmunda regalis*). All except the marsh fern grow knee-high and higher.

Tall Shrub Zone

Unlike the low-growing shrub zone comprised of members of the Heath Family, the tall shrub zone comprises several different plant families, including the Heath Family. Yet, none of these tall shrub zone species have evergreen leaves. They are all tall, deciduous shrubs that do well in full sunlight or partial shade as they begin to interface with the next zone, the conifer tree zone. Also, just like the members of the low-growing shrub zone, members of the tall shrub zone not only grow on sphagnum peat mats but do just as well on dry, acidic upland substrates within the boreal forest region. Some of the most characteristic members of the tall shrub zone include the following.

Highbush Blueberry (Vaccinium corymbosum) Heath Family

The delicious, sweet, and juicy blue fruits of the highbush blueberry have long been harvested by Native Americans and later by European settlers. Today, cultivars of this wild species of blueberry are a major source of commercially grown and harvested blueberries in North America. Blueberries are not only relished by humans but by many

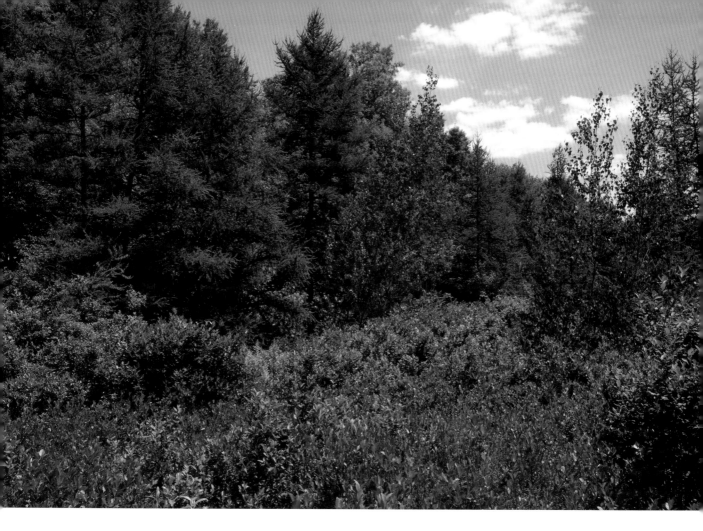

species of birds, such as robins, catbirds, wood thrushes, and cedar waxwings, as well as by mammals, from bears to white-footed mice. This, our tallest species of native blueberry, has an extensive range from the Hudson Bay region of eastern Canada south to Florida. The genus name *Vaccinium* is thought to be an ancient Latin name for the blueberry. The specific epithet *corymbosum* means "flowers in corymbs." A corymb is a more or less flat-topped inflorescence that is short and broad with the outer ring of flowers opening first.

Black Huckleberry (Gaylussacia baccata) *Heath Family*

The nearly black, edible fruits of black huckleberry ripen later than those of the blueberry. Huckleberry fruits are tasty and sweet, but they tend to be seedy with 10 seedlike nutlets in each berry. Although sometimes confused with blueberry plants, huckleberry shrubs produce reddish urn-shaped flowers, not urn-shaped white flowers, and are followed by dark purplish-black fruits. However, one of the best way to distinguish one from the other is to examine the leaves. The leaves of huckleberry are distinctly resin-dotted on both sides of the leaf but more so on the underside. Not only are these yellowish resin

Farther back from open water toward the original kettlehole shoreline, peat deposits have been building up for thousands of years. Here, the peat mat is firm enough for the establishment of low-growing bog shrubs known as the low-growing shrub zone. (Photo by Guy L. Denny.)

spots visible (especially if you hold a leaf up to the light), but this sticky resinous material can be easily rubbed off when squeezed between one's fingers. The genus name *Gaylussacia* is in tribute to French chemist Joseph Louis Gay-Lussac (1778–1850). The specific epithet comes from the Latin *bacca,* meaning "berrylike."

Mountain Holly (Ilex mucronata) *Holly Family (Aquifoliaceae)*

This species was formally placed in its own genus, *Nemopanthus,* but recent genetic studies demonstrated that it is a true holly (an *Ilex*). The mountain holly ranges from peatlands in Newfoundland west to Minnesota and then south to the dry mountaintops of West Virginia. The leaves are green above but dull and pale on the underside. The blunt leaves end abruptly and are tipped with a short, sharp spine extending beyond the margin of the leaf. Botanists refer to this as a mucronate leaf. The fruits are a purplish-crimson berrylike drupe mounted on long threadlike stalks. A drupe is simply a fruit with a pulpy coating surrounding an inner hard stone, such as a cherry. Birds like the fruits of this and other members of the Holly Family, but these fruits are not suitable for human consumption.

Winterberry (Ilex verticillata) *Holly Family*

Like the previous species, this is a true holly. Although many species within the Holly Family are evergreen, this and the previous species occurring in northern peatlands are deciduous. In autumn, winterberry is adorned with a showy

Mountain holly (*Ilex mucronata*), with its cardinal-red fruits, ranges from peatlands in Newfoundland west to Minnesota and then south to the dry mountaintops of West Virginia. It is a common member of the tall shrub zone of kettlehole sphagnum peat bogs. (Photo by Guy L. Denny.)

display of bright, glossy-red, berrylike drupes that persist in clusters on the branches long after the leaves have fallen and last well into winter. These ripe fruits are relished by birds and small mammals but not by humans. Like most hollies, winterberry is dioecious, meaning there are separate male and female plants. Only female plants produce the showy fruits. A single male shrub can pollinate up to 10 female shrubs. Many cultivars of winterberry are available in the nursery trade. Cultivars are just plants produced in cultivation by selective breeding or by vegetative propagation from wild plants to create new individuals with desirable traits, such as more and larger fruits or more colorful foliage.

Poison Sumac (Toxicodendron vernix) *Cashew Family (Anacardiaceae)*

Most people have heard of poison sumac, but many people confuse it with the red-fruited, nonpoisonous sumacs that do not occur in peatlands. Poison sumac, like its close relative poison ivy (*T. radicans*), has white berrylike drupes. All parts of the plant contain the poisonous, nonvolatile oil commonly known as urushiol to which many people are allergic, though some people are more sensitive than others. Since urushiol is nonvolatile, one has to actually come in contact with the plant directly or indirectly to trigger the allergic reaction

Seen here in flower, poison sumac (*Toxicodendron vernix*), as its name implies, contains a poisonous compound known as urushiol, which is in all parts of this shrub and causes a skin rash. Poison sumac is as much at home in kettlehole sphagnum bogs as it is in rich fens. (Photo by Guy L. Denny.)

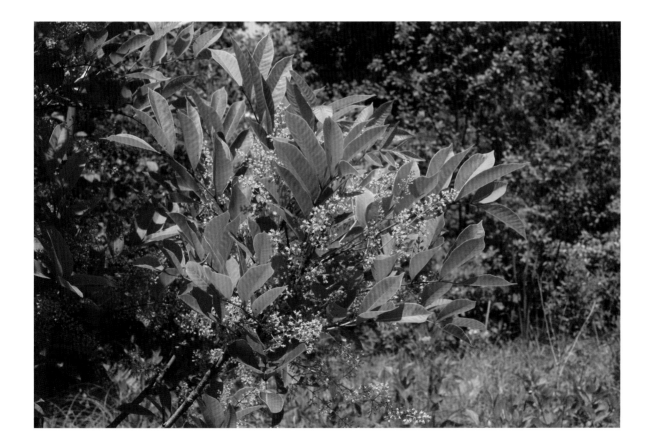

that results in an itchy skin rash. The fluid in the blisters on the skin does not spread the rash; it is simply the body's allergic reaction to the urushiol. Mice and birds, such as bluebirds, feed on the berries in winter without any ill effect. The generic name *Toxicodendron* comes from two Greek words appropriately

Poison sumac (*Toxicodendron vernix*), like poison ivy, produces an allergic skin rash. Foliage displays brilliant reds and oranges in late September. (Photo by Gary Meszaros.)

meaning "poison tree." The specific epithet *vernix* means "varnish." Karl Linnaeus mistakenly attributed poison sumac to a related eastern Asian species of tree that is a source of commercial lacquer.

Purple Chokeberry (Aronia prunifolia) Rose Family (Rosaceae)

This member of the Rose Family has five white, rounded petals that look somewhat like small apple blossoms. Some taxonomists consider purple chokeberry to be a hybrid between red chokeberry and black chokeberry, but purple chokeberry occurs where neither parent is present, suggesting that it is a bona fide species rather than a hybrid. Purple chokeberry is native from eastern Canada southward. In the northern part of its range, it is commonly found growing in the tall shrub zone of kettlehole sphagnum peat bogs. As its common name implies, the black or dark purple fruits that persist through fall and well into winter are so astringent as to pucker the mouth, causing anyone tasting them to choke. They are technically edible but not palatable. Birds seem to eat them, but they do so only as a last resort in winter.

Northern Wild Raisin also known as withe-rod (Viburnum nudum var. cassinoides) Muskroot Family (Adoxaceae)

The fruits of the wild raisin is one of this shrub's most showy features. The tiny, creamy-white flowers occurring in flat-topped clusters bloom in late spring. The flowers are then replaced by green drupes that turn a beautiful iridescent pinkish on their way to ripening, then turn red, then blue, and finally black when fully ripened. What is particularly striking about this species is that often

Purple chokeberry flowers (*Aronia prunifolia*), a member of the Rose Family, is frequently encountered in the tall shrub zone of kettlehole sphagnum peat bogs. It is considered by some taxonomists to be a hybrid between red chokeberry and black chokeberry. (Photo by Guy L. Denny.)

two or more of these colors are displayed at the same time on the same fruiting cluster. The berrylike fruit will remain on the shrub well after the leaves have fallen. The fruit was eaten by several Native American groups; however, the fruit has a single large seed surrounded by very little edible flesh. Nevertheless, what little there is of the pulp is sweet and flavorful. The alternative name, withe-rod, comes from Old English *withe,* meaning "a flexible twig," and rod means "a slender stem."

Coniferous Tree Zone

The coniferous tree zone of kettlehole sphagnum peat bogs might have gray birch (*Betula populifolia*) present along with tamarack, especially in the northeast. Some folks confuse this species with white or paper birch (*Betula papyrifera*). However, the bark of gray birch does not freely peel like that of paper birch. (Photo by Guy L. Denny.)

Although stunted in growth form, widely scattered and isolated individual specimens of shallow-rooted small conifers can appear randomly almost anywhere on the sphagnum mat. However, short conifers are especially prominent in the tall shrub zone, where seeding and saplings appear more numerous as they encroach on the tall shrub zone from the outside margins of the bog. The tall shrub zone, in turn, transitions shoreward into a mature coniferous tree zone that is often situated close to the original kettlehole basin shoreline. Here, the peat is the oldest, deepest, driest, and firm enough to support the growth and weight of larger trees. In the extreme upper northern half of Illinois, in

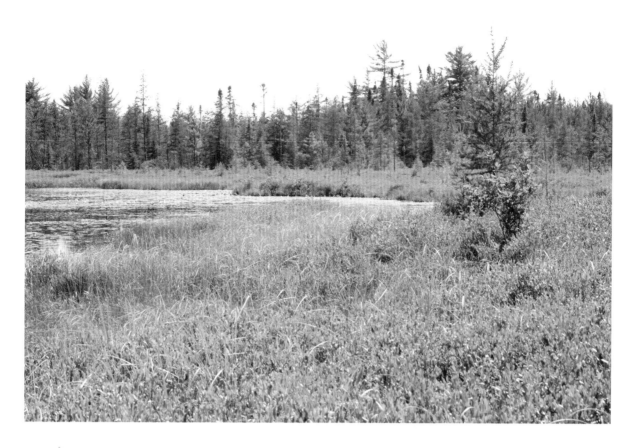

Indiana, in Ohio, and in lower Michigan, where tamarack has managed to hang on around the perimeter of kettlehole peat bogs ever since Wisconsinan glaciation, the coniferous tree zone is conspicuously dominated by a dense stand of mature tamarack mixed in with a few yellow birch (*Betula alleghaniensis*), red maple, and, in some cases, gray birch (*Betula populifolia*). Tamarack is one of only two species of deciduous conifers native to eastern North America. In autumn, after the hardwoods have dropped their leaves, tamarack needles turn a beautiful golden yellow before falling to the ground. The only other deciduous conifer native to eastern North America is bald cypress (*Taxodium distichum*), a tree of the peatlands in the Deep South.

In the glaciated southern regions of Illinois, Indiana, and Ohio, a coniferous tree zone might be absent around most kettlehole sphagnum peat bogs because tamarack, a northern species, does not do well that far south. Here, the tall shrub zone typically grades right into a deciduous swamp forest tree zone. Yet in the northern Great Lake states within the southern boreal forest region, the coniferous tree zone is quite pronounced not only with the presence of tamarack but also with more northerly occurring black spruce, white pine, and perhaps even some balsam fir (*Abies balsamea*). Like members of the Heath Family, and indeed like most bog plants, tamarack and black spruce

The sphagnum mat of kettlehole sphagnum peat bogs north of the Great Lakes region are often invaded by black spruce, a boreal species that no longer occurs in Ohio and adjacent states. (Photo by Guy L. Denny.)

also depend on mycorrhizae to enable them to access nutrients in an otherwise nutrient-poor bog mat environment.

Bog conifers have had considerable utility to native peoples. The long, pliable roots of both tamarack and black spruce were used by Native American Algonquin people to lace plates of bark from white birch (*Betula papyrifera*) together to make birchbark canoes as well as to make woven baskets and bags (Harlow and Harr 1969). The Ojibwa also used the sticky sap of both tamarack and black spruce as a glue to fasten and waterproof seams of the birchbark plates (Newmaster 1997). The genus name for spruce trees, *Picea,* is a Latin word meaning "pitch," referring to this sticky, water-sealing, glue-like sap.

The coniferous tree zone can be quite extensive and intermixed with low and tall shrubs within the boreal forest regions of North America. However, well south of the boreal region, the coniferous tree zone, where it exists, is well defined and narrow, surrounding open kettlehole sphagnum bog lakes. Tom S. Cooperrider (Kent) Bog State Nature Preserve, just south of Kent, Ohio, is an exception. Except for the lagg, there is no longer any open water. The lake has totally filled in with peat. The entire basin has essentially transformed into a tamarack coniferous tree zone with a nearly impenetrable understory of tall shrubs, mostly highbush blueberry. A boardwalk comprised of recycled

The Tom S. Cooperrider (Kent) Bog State Nature Preserve, located on the outskirts of Kent, Ohio, is an outstanding example of a large kettlehole sphagnum peat bog that, over thousands of years, has filled with peat, eliminating the original open-water glacial lake. It is now primarily a tamarack forest with an understory of bog species, including a dense stand of bog shrubs. (Photo by Guy L. Denny.)

plastic materials has been constructed to allow visitors to access and explore the site. In those more southerly regions outside of the range of tamarack, the tall shrub zone typically grades into a swamp forest zone right up to the old shoreline of the original kettlehole lake basin.

Swamp Forest Zone

In the absence of native conifers, deciduous trees occupying the swamp forest zone include red maple (*Acer rubrum*), silver maple (*A. saccharinum*), yellow birch (*Betula alleghaniensis*), black gum (*Nyssa sylvatica*), black ash (*Fraxinus nigra*), green ash (*F. pennsylvanica*), and swamp white oak (*Quercus bicolor*). A lush, light-green carpet of *Sphagnum* moss is usually still present even under the shade of the tall trees, yet these are usually shade-tolerant species of *Sphagnum* mosses, such as pom-pom peat moss (*Sphagnum wulfianum*), spiky peat moss (*S. squarrosum*), blunt-leaved peat moss (*S. palustre*), and graceful peat moss (*S. girgensohnii*). Ferns, especially royal, interrupted, and cinnamon ferns, are also abundant in this vegetation zone beneath the swamp forest trees.

A number of rare boreal wildflowers occur on the forest floor of the kettle-hole swamp forest zone. Among these species occurring in disjunct populations well south of the boreal region, even as far south as northern Ohio, include goldthread (*Coptis trifolia*), Canada mayflower (*Maianthemum canadense*), starflower (*Lysimachia borealis*), and wild calla (*Calla palustris*). Farther

Left: Royal fern (*Osmunda regalis* var. *spectabilis*) is one of the tall ferns, along with interrupted fern and cinnamon fern, that commonly occurs within the transition zone between the low-growing shrub zone, the tall shrub zone, and on into the peatland conifer tree zone of kettlehole sphagnum peat bogs. (Photo by Guy L. Denny.)

Right: Cinnamon ferns (*Osmundastrum cinnamomeum*) are one of the more common large ferns occurring on the bog mat as well as within the transition zones between the low-growing shrub zone, the tall shrub zone, and on into the peatland conifer tree zone of kettlehole sphagnum peat bogs. (Photo by Guy L. Denny.)

Left: In spring, the small white flowers of goldthread (*Coptis trifolia*), a member of the Buttercup Family, adorn mossy hummocks. (Photo by Gary Meszaros.)

Right: Pink lady's-slipper orchids, also known as stemless moccasin flower orchids (*Cypripedium acaule*), bloom in spring on acidic soils including the peat deposits of bog forest communities. (Photo by Gary Meszaros.)

north, there are such additional rarities but in greater abundance as bluebead lily (*Clintonia borealis*), twinflower (*Linnaea borealis*), gay-wings (*Polygala paucifolia*), creeping snowberry (*Gaultheria hispidula*), bunchberry (*Cornus canadensis*), and stemless lady's-slipper orchid (*Cypripedium acaule*).

The Lagg

Kettlehole sphagnum bogs are usually surrounded by a moat referred to as a lagg, a term of Swedish origin. Laggs can vary considerably in size, depth, and shape. Laggs typically occur between the swamp forest zone and the shoreline of the original kettlehole lake basin. This is where mineral-rich and well-oxygenated runoff water from adjacent uplands accumulates and leaf litter and shade from adjacent trees eliminate living *Sphagnum* moss, thus accelerating decomposition of the original peat deposits. The resulting trough or depression formed around the perimeter of the bog mat holds less acidic and more nutrient-rich waters. Laggs that form expansive, wide-open but shallow basins typically support marsh vegetation. Where the lagg is shaded

by adjacent tall trees, and is narrow and deep, there might be just somewhat of a barren murky-water barrier between the shoreline and the edge of the swamp forest zone.

Because of the dense shade and deepness of the water, few plants occupy a deep, narrow lagg, which might also significantly limit human access to the bog mat. In the more mineral-rich waters of a wide and open shallow lagg, a host of typical marshland plants abound, including such species as three-way sedge (*Dulichium arundinaceum*) and wool-grass (*Scirpus cyperinus*), along with several other species of marsh sedges, wetland grasses, swamp loosestrife, bittersweet nightshade (*Solanum dulcamara*), and various species of wetland ferns. Woody species, including buttonbush (*Cephalanthus occidentalis*), meadow-sweet (*Spiraea alba*), swamp rose (*Rosa palustris*), red maple, poison sumac, and highbush blueberry, might also be present. In more northern wetlands, speckled alder (*Alnus incana*), various species of willows, and sweet gale (*Myrica gale*), with its fragrant leaves, might be widespread and abundant in open lagg habitats.

Kettlehole sphagnum bogs are usually surrounded by a moat referred to as a lagg. Laggs can vary considerably in size, depth, and shape. (Photo by Guy L. Denny.)

Natural Plant Succession

Ultimately, south of the boreal forest region, even the bog forest zone surrounding kettlehole sphagnum peat bogs will be replaced by a swamp forest community typical of these more southern latitudes. Yellow birch and tamarack will disappear from the landscape and be replaced by elm, ash, and wetland oaks—primarily pin and swamp white oak. The carpet of *Sphagnum* moss will disappear beneath a thick cover of leaf mulch. It may take several hundred to several thousands of years, but, eventually, only the presence of peaty soils supporting a swamp forest community will reveal that the kettlehole peat bog ever existed. That is how natural succession works, with one plant community paving the way for, and being replaced by, another.

Kettlehole Sphagnum Peat Bogs as Time Capsules

Kettlehole peat bogs give us a window into past climatic changes. In 1925, while studying at the Iowa Lake Laboratory at Okoboji, Ohio-born scientist Paul B. Sears came across the works of noted Swedish scientist Lennart von Post, who had written about how pollen preserved in peat and other sediments could be used in order to determine past changes in climate. Thus began Sears's research of analyzing pollen profiles from bogs and lake sediments in the north-central states. He pioneered this type of research in North America, which many researchers continue to this day. By identifying fossil pollen collected at various depths within kettlehole bogs, determining under what prevailing climatic conditions those species would have grown, and later by using radiocarbon dating to determine their relative age, Sears went on to earn his PhD from the University of Chicago. He finished his long and distinguished teaching career as professor of botany at Yale University and clearly opened the door to our understanding of post–Wisconsinan Glacier changes in the vegetation of the Midwest.

Shortly after a kettlehole lake is formed, boreal vegetation becomes established around it. Each spring, pollen shed by surrounding vegetation is preserved within peat deposits that accumulate over the years in these bog lakes. Sears's pollen research revealed a sequence of spruce and fir pollen at the lowest peat depths in kettlehole peat bogs, indicating a cold, moist climate that existed in close proximity to the retreating glacial ice. Higher up in the peat profile, pine pollen becomes more abundant as spruce and fir pollen drop out, indicating a trend toward a warmer and drier climate. Next, pollen from hardwoods and hemlocks become abundant, indicating a return to somewhat cooler and moister climatic conditions. Samples of peat collected just above this level reveal pollen from oak and hickory become abundant along with a

significant increase in grass pollen. This demonstrated a much warmer and dryer postglacial period known as the xerothermic period or Hypsithermal Interval, a time around 4,000 to 6,000 years ago when tallgrass prairies extended their range eastward as hardwood forests began to die out from extended periods of drought during this period. Finally, at the uppermost layers of peat, pollen from more recent forest types make a reappearance, indicating another change in climate indicative of a return to a cooler, moister climate more like our present-day climate.

Radiocarbon Dating

The key to Sears's research was the use of radiocarbon dating. In 1949, scientist Willard Libby discovered the technique of radiocarbon dating. A natural radioactive isotope of carbon (carbon-14) is present in all living matter. When a plant or animal dies and growth ceases, the carbon-14 within their tissues begins to break down (radioactive decay). This decay rate is constant, measurable, and unaffected by any natural chemical or physical condition of the environment. Accordingly, the longer the organism has been dead, the less carbon-14 remains in its tissues. Scientists can consequently determine how long ago the organism died. Fragments of wood, bone, and shell embedded in peat alongside tree pollen are radiocarbon-dated to find out how long ago the adjacent pollen was deposited. Unfortunately, the radiocarbon isotope content becomes too low to accurately measure samples older than around 50,000 to 70,000 years. Nevertheless, such variation accurately covers the entire period of Wisconsinan glaciation, giving scientists the ability to age peat samples retrieved from peat bogs and thus revealing secrets of the past.

From Oligotrophic to Minerotrophic Peat Bogs

Kettlehole sphagnum peat bogs are known as oligotrophic peatlands or poor fens. They are intermediate between ombrotrophic, raised true bogs, such as those occurring along the coastline of Maine on into Canada, and mineral-rich or minerotrophic rich fens of the Midwest. The basic difference is that poor fens, referenced previously as kettlehole sphagnum peat bogs, are based on a semi-floating blanket of sphagnum peat situated over deep basins containing essentially non-flowing, anaerobic, acidic water. Minerotrophic rich fens, however, are primarily based on a relatively flat plain of alkaline marl fed by highly calcareous, mineral-rich, flowing groundwater. Both of these peatland ecosystems owe their existence to Wisconsinan glaciation. Under certain circumstances, over thousands of years, rich fens can in some instances be transformed into sphagnum peatlands.

pH

Kettlehole sphagnum bogs have a pH ranging from approximately 4.5 to 6.0, while extremely rich fens typically have a pH of 6.0 to 8.5 (Anderson 1997). It should be noted that pH ranges are subject to seasonal variations as well as variations within any given bog or fen at different times of the year. So, what exactly is pH, and what does it mean? The concept of pH was originally introduced in 1909 by Danish chemist Soren Sorenson. This is a logarithm scale used to specify how acidic or alkaline (basic) a water-based solution is. The pH scale runs from 0 to 14 and measures all hydrogen-ion concentrations in solution. A pH of 7.0 is neutral, neither acidic nor basic. Numbers below pH 7 are acidic solutions, and numbers above pH 7 represent basic or alkaline solutions.

Because pH is a logarithmic scale (to the base 10), a change of one pH unit represents a tenfold difference in hydrogen-ion concentration. This means that each whole pH value below 7.0 is 10 times more acidic than the next whole number. For example, pH 6.0 is 10 times more acidic than neutral pH 7.0 (neutral pure water). At pH 5.0, the solution is 10 times more acidic than pH 6.0 but 100 times (10 times 10) more acidic than a neutral solution of pH 7.0. Accordingly, pH 4.0 is 10 times more acidic than pH 5.0 but 1,000 times (10 times 100) more acidic than pure water at pH 7.0. Conversely, pH 8.0 is 10 times more alkaline than neutral distilled water at pH 7.0. At pH 9.0, a solution is 10 times more alkaline than at pH 8.0 but 100 times (10 times 10) more alkaline than pH 7.0. Sphagnum peat bogs are acid ecosystems, less than pH 7.0, while rich fens are alkaline ecosystems with a pH greater than 7.0.

Minerotrophic Rich Fens

The term fen wasn't used in the United States until 1943, when W. A. Anderson published "A Fen in Northwestern Iowa" in the journal *American Midland Naturalist*. Before then, the term fen had been used as a colloquial term for some time in Great Britain in reference to their calcareous wetlands. The site studied by Anderson in northwestern Iowa was a calcareous peatland based on marl, with a very diverse and fascinating assemblage of plants. Botanists soon realized this fen ecosystem was not at all unique to Iowa but rather now recognize and know it to be scattered throughout much of glaciated North America. Up until 1943, these peatlands had simply been labeled collectively as bogs. Rich fens are alkaline peatlands, but unlike acidic sphagnum peat, fen peat is comprised of graminoid peat, which is formed primarily from partially decayed wetland grasses; grasslike sedges; and rushes, but not *Sphagnum* moss. Graminoid peat is only slightly acidic to alkaline. Another very significant difference between kettlehole sphagnum peat bogs and rich fens is in the concentrations of calcium in the groundwater. Calcium carbonates in the groundwater of rich fens may equal 20 to 30 ppm (parts per million), while acid bog water holds only about 0.3 to 2 ppm of calcium (Crum 1991).

Formation of Marl

The Wisconsinan Glacier deposited massive loads of porous limestone and dolomite-rich gravels in the form of moraines, eskers (long linear or sinuous ridges of stratified sand and gravel), and extensive outwash gravel plains. Dolomite is just a more resistant limestone with a high magnesium content. It is sometimes referred to as "dolostone." These glacial gravel deposits are the

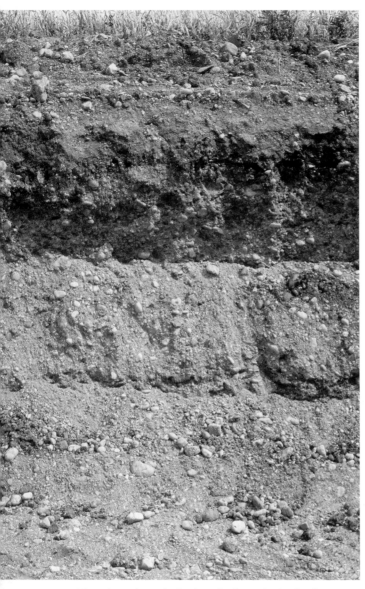

The Wisconsinan Glacier deposited massive loads of porous limestone and dolomite-rich gravels. As rainwater percolates down through these gravels, it becomes enriched with water-soluble calcium and magnesium bicarbonates. These gravel deposits are the ice age–related vehicle for the establishment of rich fens. (Photo by Guy L. Denny.)

ice age vehicle for the establishment of rich fens. As rainwater (H_2O) falls from the sky, it combines with atmospheric carbon dioxide (CO_2), forming mild carbonic acid (H_2CO_3). Rainwater typically has a pH of about 5.6, but it can be as low as 4.1 to 4.5 with the addition of atmospheric sulfurous acids emissions from coal-burning power plants. These acids tend to dissolve limestone-based minerals.

As rain soaks into the ground and then percolates downward through these limestone and dolomitic gravels, it dissolves out calcareous materials, forming water-soluble calcium and magnesium bicarbonates and enriching the flowing groundwater. By the time this very cold, oxygen-deficient, mineral-enriched groundwater emerges, it is highly charged with soluble calcium and magnesium bicarbonates at temperatures ranging from 50 to 54 degrees Fahrenheit. Depending on local hydrology, these waters can flow out of the ground in fast-moving, high-pressure artesian wells or in slow-flowing springs or seeps. In some instances, these waters can flow even from fractures in limestone bedrock. As it emerges from underground, the water spreads out across the landscape in all directions through a network of multiple streamlets, often culminating in a main faster and deep-flowing stream. The results are usually widespread, very shallow pools of water covering the immediate landscape upon which layers of marl, a lime-rich muddy silt, are deposited. Many of these pools that appear shallow are actually filled with a very watery marl and peat mix. Upon stepping into one of these pools, one can sink up to the knees and sometimes deeper.

Upon emerging from underground, the cold water suddenly begins to warm, and as it does, carbon dioxide is quickly released, leaving behind calcium and magnesium carbonates in a solid form known as marl and sometimes also as tufa, a very porous, calcium carbonate rock. Marl and tufa compose the substrate upon which these highly alkaline wetlands are primarily based. Marl and tufa can also be extracted from groundwater as it

becomes shallow surface waters lying over marl flats, where slow evaporation releases carbon dioxide and, in the process, leaves behind calcium carbonate. Lastly, when certain fen plants, such as *Chara,* a green algae (Caraceae), extract carbon dioxide from water during photosynthesis, a calcium carbonate crust is deposited on the plant. *Chara* plants are often submersed in deeper fen waters and are rough and brittle to the touch due to the calcium carbonate deposited on them during photosynthesis. For that reason, *Chara* plants are commonly known as stoneworts (stone plants). *Chara* plants also have an unpleasant smell of hydrogen sulfide as a result of the metabolic processes associated with the deposition of calcium carbonate. As these plants die, the calcium carbonate deposited on them becomes part of the marl substrate. In all three cases—that is, cold water quickly warming, slow evaporation of water from shallow marl flats, and aquatic plants extract carbon dioxide—marl is left behind and deposited across the ground over thousands of years in thick layers. Marl can also contain calcium carbonate deposited from the shells of small, dead aquatic crustaceans. Marl, not sphagnum peat, is the substrate upon which rich fens are based with an overlying layer of graminoid and well-decomposed, black mucky peat.

Chara is a green algae that extracts carbon dioxide from water during photosynthesis, depositing a calcium carbonate crust on the plant. This is one of the main contributors to marl deposits in a rich fen ecosystem. (Photo by Guy L. Denny.)

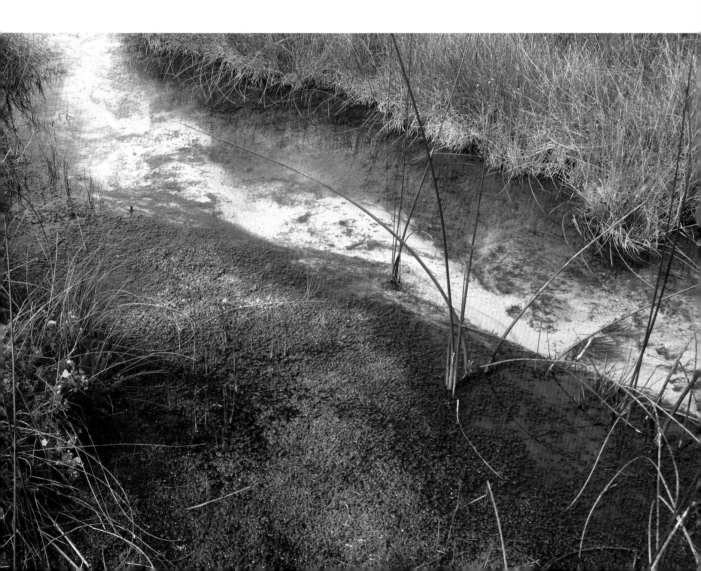

Limiting Factors in Rich Fens

The limiting factors associated with rich fens are similar to those associated with kettlehole sphagnum peat bogs. Rich fens are inhospitable environments for plants that cannot cope with the harsh environmental conditions. Such conditions include low-nutrient availability, high alkalinity, low oxygen levels, waterlogged substrates, and cold root-level temperatures. Nutrient availability in a rich fen is limited by pH. Above pH 6.5, phosphorus, nitrogen, and potassium become immobilized and unavailable to plant life. Many cations are precipitated from alkaline substrates, causing elements such as iron, manganese, copper, and zinc to be unavailable for plants. Above pH 7.0, phosphorus also becomes less available (Crum 1988). Since the pH of rich fens generally falls between pH 7.5 and 8.5, the plants growing there are limited by nutrient availability.

Distribution of Rich Fens on the Landscape

Watching a strong flow of calcium-rich and magnesium-rich groundwater emerging from a hillside of glacial outwash gravel, it is easy to understand how highly alkaline, cold, low oxygen meltwaters flowing out of a glacial wall of ice could set the stage for the development of rich fen plant communities. Rich fens developed along the newly exposed substrates emerging from beneath the retreating wall of glacial ice as well as around the shores of numerous glacial lakes. In southern latitudes, species of rich fens would undoubtedly quickly colonize these newly exposed landscapes as they followed the glacier's retreat northward along with other boreal vegetation.

However, as the immense wall of ice retreated farther north, the impact of the glacier on the regional climate diminished. Eventually, any boreal vegetation, including rich fen species, that remained stationary were doomed to be displaced by vegetation more at home in the continuing warming climate. Only the offspring of these plants, generation after generation continually recolonizing the newly exposed substrates while following the glacial ice northward, would ultimately survive and recolonize today's boreal forest region. But then how is it that we still have rich fen species surviving in glaciated southern latitudes, disjunct hundreds of miles from their more boreal counterparts? Just like some kettlehole boreal bog species that were able to remain behind because of special environmental conditions associated with kettlehole sphagnum peat bogs, rich fen species were also able to stay behind and survive by taking advantage of new favorable environmental conditions that approximated those that occurred while the glacial ice was just north of the newly emerging Great Lakes. These favorable environmental conditions

included cold, highly alkaline waters flowing out of the ground instead of out of melting glacial ice.

As the wave of boreal vegetation following the glacier northward encountered flowing cold springs, hillside seeps, and even some kettle depressions fed by highly alkaline, cold groundwaters, these special environmental conditions (rich fen–limiting factors) provided a favorable habitat for rich fen species to stay behind and flourish. This would account for why disjunct rich fen communities of today are so widely distributed across our glaciated landscape south of the boreal forest region of North America; they, too, are surviving relicts of the Ice Age.

Just as natural succession in a kettlehole peat bog causes a kettle lake to eventually completely fill with peat and transition from a kettlehole sphagnum peat bog into a swamp forest community, natural succession also takes place in rich fen communities. Once a thick blanket of graminoid peat covers the entire fen community—cutting off and insulating the flowing groundwater and that water's impact on fen vegetation—the rich fen community is ultimately replaced by a marsh or swamp-forest community. The deepest kettlehole peat bogs have been able to survive to this day because their great depths have slowed down the lake-fill process. Having the most extensive aquifers and therefore the strongest volume of alkaline water discharge to flush away peat deposits before they build up a smothering blanket of peat, rich fens have also been able to survive and thrive.

Plant Zones

There are distinct zones of fen vegetation in a rich fen just as there are within kettlehole sphagnum peat bog communities. However, unlike the concentric, more regimented plant zones of kettlehole bogs, the different plant zones present within a rich fen are neither concentric nor as regimented. They start out with the open marl flats, where emerging groundwater has the greatest influence on fen vegetation. Thereafter, plant zones progress outward to the fen meadow and tall shrub zones and finally to the transition zone, where fen meadow and tall shrub zones graduates into swamp forest. Over several thousand years, the swamp-forest zone can completely replace the fen ecosystem.

Rich fen peatland communities are reportedly among the most species-rich and diverse ecosystems in North America. The number of plant species in a rich fen is far greater than in a kettlehole sphagnum peat bog. It is beyond the scope of this book to identify all fen species, but as we explore each plant zone in a rich fen, we will identify some of the more typical and characteristic species encountered in rich fen ecosystems, especially those in the southern Great Lakes region. Keep in mind that no two rich fens are exactly alike any

more than any two kettlehole sphagnum peat bogs are exactly alike. However, we can generalize enough to provide a reasonably accurate picture of the typical vegetation present in a rich fen ecosystem.

Open Marl Flats

Open marl flats are the epicenter of a rich fen ecosystem. This is where the newly emerging, highly alkaline, very cold, and oxygen-deficient groundwater has the greatest impact on fen vegetation. Consequently, open marl flats with their shallow pools of water, numerous flowing streamlets, and water-saturated marl and tufa deposits are sparsely vegetated. Few species of plants can survive in this harsh environment, but those that do are a select and very special few. Among these are marsh arrow-grass (*Triglochin palustris*) and seaside arrow-grass (*T. maritima*). Contrary to their common names, these are not grasses; rather they are members of the Arrow-grass Family (Juncaginaceae). Both are halophytes (plants adapted to saline water and soil) able to growing in brackish waters of salt marshes and other salt-rich habitats. Calcium carbonate is also a salt that creates a special challenge for plants. Since salt in a solution has a higher concentration than the liquids in the cells of root tissue, the tendency is for the salt solution to pull water out of a plant. Halophytes have special

Open Marl Flats: Cedar Bog State Nature Preserve in west-central Ohio has one of the largest, finest, and most biologically diverse open marl flats zone of all fens in the state. Notice the abundance of white cedar trees around the perimeter of this marl flat's open sedge meadow. (Photo by Guy L. Denny.)

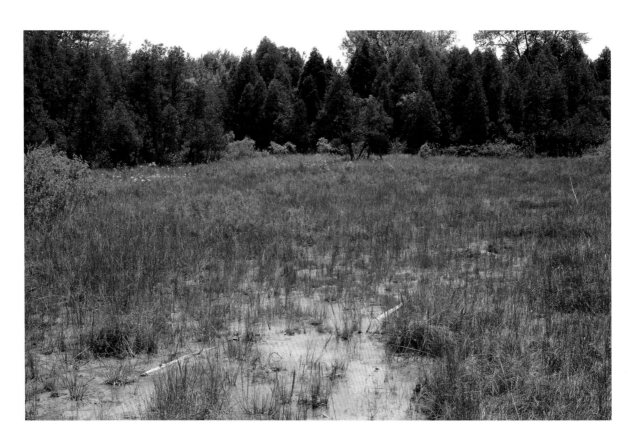

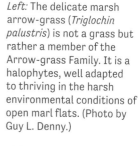

Left: The delicate marsh arrow-grass (*Triglochin palustris*) is not a grass but rather a member of the Arrow-grass Family. It is a halophytes, well adapted to thriving in the harsh environmental conditions of open marl flats. (Photo by Guy L. Denny.)

Right: Seaside arrow-grass (*Triglochin maritima*) is a frequent member of rich fen marl sedge meadows. Seaside arrow-grass is similar to marsh arrow-grass but much larger. As its name implies, this is a species also found growing in brackish waters of salt marshes. (Photo by Guy L. Denny.)

Below: The walking spike rush (*Eleocharis rostellata*) gets its name from its very long, arching leafless stems that reach out over marl flats. Where the tips contact the marl surface, they take root, resulting in new arching stems that emerge and form large conspicuous loops firmly anchored to the ground. This is one of the most common species typical of the open marl flats of high-quality rich fens in the southern Great Lakes region. (Photo by Guy L. Denny.)

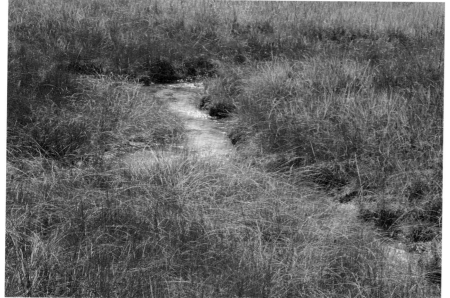

osmotic adaptations to prevent this from happening, which is why they can grow where few other plants cannot, such as in salt marshes and on marl flats.

Members of the Sedge Family (Cyperaceae) are well represented in the open marl flats. One of the more interesting and most conspicuous is walking spike rush (*Eleocharus rostellata*), which is also a halophyte and able to grow in salt marshes. In spite of its common name, this is a sedge (Cyperaceae), not a rush (Juncaceae). The walking spike rush gets its name from its very long,

Green-keeled cotton grass (*Eriophorum viridicarinatum*) is a species of open marl flats. This is a boreal species occurring throughout much of Canada and north through Alaska. The southernmost extent of its range occurs in central Indiana and west-central Ohio. It is now extirpated from Illinois. Green-keeled cotton grass only grows in rich fens and blooms in late spring. (Photo by Guy L. Denny.)

flattened, arching leafless stems that reach out over the marl flats. Where the tips contact the marl surface, they take root, resulting in new arching stems that emerge and form conspicuous loops firmly anchored to the ground. As one catches one's foot in one of these many well-rooted loops, the stem often breaks with a loud *pop,* announcing the presence of walking spike rush without having to even look down at it for identification.

Another interesting member of the Sedge Family growing in the marl flats is the green-keeled cotton grass (*Eriophorum viridicarinatum*). This boreal species occurs throughout much of Canada and north through Alaska. The southernmost extent of its range occurs in central Indiana and west-central Ohio. It is now extirpated from Illinois. Green-keeled cotton grass gets its common name from the prominent green midrib on the floral scale on each of its dangling cottony seed heads. Unlike tawny cotton grass, which only occurs in acidic peatlands and blooms in late summer, green-keeled cotton grass (also sometimes called thinleaf cotton grass) only grows in rich fens and blooms in late spring.

Other conspicuous species found growing there are the very dainty Kalm's lobelia (*Lobelia kalmii*), named by Karl Linnaeus to honor his student, Peter Kalm. Kalm's lobelia ranges across Canada and northern United States. This species is a calciphile, which is a plant that thrives in alkaline soils. Two other calciphiles typically encountered in marl flats are false asphodel (*Triantha glutinosa*) and white camas (*Anticlea elegans*). The stalks and upper stem of false asphodel are densely covered with reddish, sticky glandular hairs. White camas, also known as death camas, contains a very poisonous alkaloid that if ingested can be fatal to livestock and humans alike. One of the prettiest

and most interesting of these calciphilic plants is common grass-of-Parnassus (*Parnassia glauca*). Illinois, Indiana, and Ohio lie along the southern most range limit of this very boreal species. It was named by first-century AD Greek physician and naturalist Dioscorides. Common grass-of-Parnassus is not a grass but rather a member of the Bittersweet Family (Celastraceae). Its common name as well as generic epithet, *Parnassia,* honors Mount Parnassus in Greece.

Sedges are among the most dominate species encountered in the cold, anaerobic open marl flats of rich fens. Yet, without oxygen available in anoxic marl substrates, plant roots cannot respire and, consequently, cannot survive. To overcome this barrier, all sedges have aerenchyma tissue in their stems that allow gases, including oxygen, to reach the roots and enable metabolism to occur. Oxygen also leaks out around the roots to form a small area known as an oxidized rhizosphere. The role of this protective root zone is to detoxify chemicals that produce anaerobic conditions in close proximity to the roots. This adaptation is also how many other plants growing in marl flats, including the two species of arrow-grass, are able to survive in this oxygen-deficient environment. In order to access nutrients in nutrient-poor environments such as marl flats, some species are also deep rooted, reaching beneath the relatively

Left: The genus name Kalm in Kalm's Lobelia (*Lobelia kalmii*) honors one of Karl Linnaeus's star students, Peter Kalm, who collected plant specimens extensively in the United States for his teacher. (Photo by Guy L. Denny.)

Right: White camas (*Anticlea elegans*) is frequently encountered in high-quality marl flats. Also known as white death camas, this species contains a very poisonous alkaloid that, if ingested, can be fatal to livestock and humans alike. (Photo by Guy L. Denny.)

thin layer of marl into the more nutrient-rich underlying mineral soils. This growth habit is especially true of deep-rooted prairie plants that also inhabit some fens.

Fens typically support an abundance of sedges. Among the most characteristic sedges occurring in the open marl flats of rich fens are large yellow sedge (*Carex flava*), small yellow sedge (*C. cryptolepis*), green sedge (*C. viridula*), brown bog sedge (*C. buxbaumii*), woolly sedge (*C. pellita*), dioecious sedge

Large yellow sedge (*Carex flava*) is a common sedge found growing in the open marl flats of rich fens. (Photo by Guy L. Denny.)

One of the most characteristic sedges of the open marl flats is small yellow sedge (*Carex cryptolepis*). Sedges are among the most dominate species encountered in the cold, anaerobic open marl flats of rich fens. (Photo by Guy L. Denny.)

(*C. sterilis*), autumn sedge (*Fimbristylis autumnalis*), low nut rush (*Scleria verticillata*), hair beaked rush (*Rhynchospora capillacea*), white beak rush (*R. alba*), hard-stemmed bulrush (*Schoenoplectus acutus*), and three-square bulrush (*S. pungens*), the last so named for its distinctive three-sided stem. The genus name *Schoenoplectus* comes from the Greek words *schoinos,* meaning "a rush or reed," and *pleko,* meaning "to weave." Ojibwa and other Algonquian peoples used bulrushes for weaving mats and bedding (Newmaster1997). Finally, twig-rush (*Cladium mariscoides*), which in spite of its common name is also a sedge and not a rush, is often found growing in abundance within the open marl flats of rich fens. There is only one other member of the genus *Cladium, C. jamaicense,* which is the very dominant and well-known saw-grass that covers hundreds of square miles in the Florida Everglades.

Species of rushes in the Rush Family (Juncaceae) also have a presence on the open marl flats, appearing somewhat later during the growing season. Most notably, these include Baltic rush (*Juncus balticus* ssp. *littoralis*), knotted rush (*J. nodosus*), Dudley's rush (*J. dudleyi*), and small-headed rush (*J. brachycephalus*). Some species of grasses (Poaceae) also occur here, including marsh wild-timothy (*Muhlenbergia glomerata*), fowl manna grass (*Glyceria stricta*), and tufted hair grass (*Deschampsia cespitosa*).

Several species of plants that occur on the sphagnum lawns of kettlehole peat bogs are also just as much at home in the open marl flats of rich fens. These include bog orchids rose-pink and rose pogonia. Also, carnivorous plants occurring in rich fens as well as in sphagnum peat bogs include round-leaved sundew and northern pitcher plant. Pitcher plants growing in rich fens have somewhat of a different appearance than their counterparts growing in kettlehole sphagnum peat bogs. They are generally smaller and stubbier,

Left: Brown bog sedge (*Carex buxbaumii*) is one of the most common and characteristic sedges of rich fen sedge meadows. It is easily identified by its brown, chevron-like markings. (Photo by Guy L. Denny.)

Center: Woolly sedge (*Carex pellita*) is one of the most common species of sedges growing in the wettest areas in open marl flats of rich fens within the southern Great Lakes region. In northern latitudes, its rhizomes form a mat in boreal rich fens where there is standing shallow waters. (Photo by Guy L. Denny.)

Right: Twig rush (*Cladium mariscoides*), actually a sedge, is often encountered in sedge meadows within the open marl flats of rich fens. The only other member of this genus in North America is *Cladium jamaicense,* the sawgrass that covers hundreds of square miles in the Florida Everglades. (Photo by Guy L. Denny.)

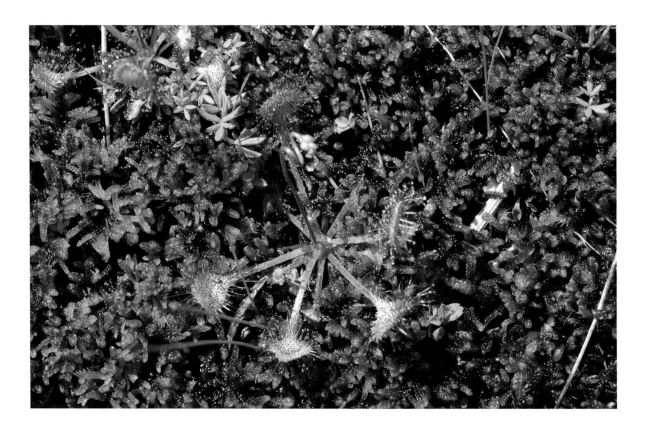

Round-leaved sundew (*Drosera rotundifolia*) is a fascinating carnivorous plant that occurs in both acidic kettlehole sphagnum peat bogs and in alkaline rich fens, such as the one photographed here growing on brown moss along the boardwalk at Prairie Road Fen State Nature Preserve in Clark County, Ohio. (Photo by Guy L. Denny.)

and they are often darker red. At one point there was an effort to differentiate these plants as a separate variety, the variety *ripicola*. However, as part of Adrienne J. Mandossian's PhD dissertation, the Michigan State University student performed reciprocal-transplant experiments and discovered that plants moved from rich fens and replanted in sphagnum peat bogs assumed the more robust appearance of the sphagnum bog plants after a few growing seasons (Mandossian 1965). Northern pitcher plants occur in only two rich fens in the northern half of Ohio, where they are just barely surviving. In rich fens situated just north of Ohio, they become more commonplace and continue to be more common in rich fens farther north.

Two other species of carnivorous plants found in the marl flats are horned bladderwort (*Utricularia cornuta*) and flat-leaved bladderwort (*U. intermedia*). The suffix *wort* is Old English meaning "plant." Although their bright yellow flowers stand out, the rest of these semiaquatic species are not as conspicuous. The bladder-bearing branches and stems lie partially buried in the wet marl. Bladderworts capture prey with their small leaf-bearing tiny bladders or sacs known as utricles. Hairs at the openings of each bladder serve as triggers. When these trigger hairs are tripped by a tiny aquatic organism, the door of the bladder springs open drawing water along with the prey into the bladder. Enzymes within the bladder then digest the prey. The process of triggering

the hairs to the closing of the bladder door behind the prey takes as little as two-thousandths of a second, faster than can be detected by the human eye (Johnson 1985). However, if you pick up bladderworts and listen closely, you can hear the popping sound of the utricles as they pop open.

Rich fens, at least in the southern and western part of their range, tend to have little if any *Sphagnum* moss present. Instead, they have what ecologists call brown mosses. Brown mosses have an appearance of what most of us would recognize as a moss. They don't look at all like *Sphagnum* mosses. Certain species of these brown mosses are strongly calciphilic, including swollen scorpion moss (*Scorpidium scorpioides*), which is also known as scorpion feather moss, rusty claw-leaved feather moss (*Drepanocladus revolvens*), and green feather moss (*D. vernicosus*)—just to name three of the more common species found growing in rich fens.

Fen Meadow

Farther away from the flowing surface waters of the open marl flats, where graminoid peat cannot be flushed away, a blanket of well-decomposed, mucky, waterlogged, black peat forms. The farther removed from moving water, the thicker this mat becomes. Where this peat mat is relatively thin, sprawling, interlaced roots and rhizomes form a buoyant mat over the surface of standing groundwater, which can support the weight of a person. Under the weight of a person, it can quake up and down just like the quaking mat of a sphagnum peat

The fen meadow is typically the largest and most species-rich area of a fen. (Photo by Guy L. Denny.)

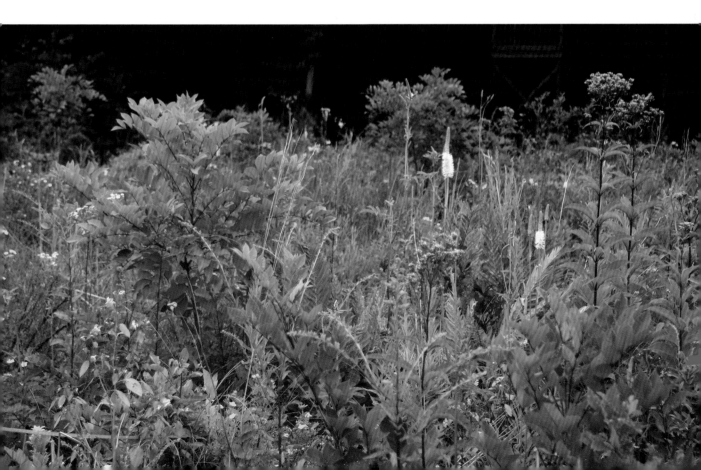

bog. This is the beginning of the fen meadow zone, where species diversity is highest. Many of the plants found growing in the open marl flats survive here but only where the peat mat is shallowest, and their roots are still under the strong influence of the flowing or standing cold, alkaline groundwaters below. In its early stages, this floating mat constitutes the quaking mat of a rich fen.

The fen meadow is a botanist's paradise. Perhaps the most ubiquitous and conspicuous member of the fen community is shrubby cinquefoil (*Dasiphora fruticosa*), a member of the Rose Family (Rosaceae). This attractive, low-growing, rounded, and many-branched deciduous shrub with its attractive bright yellow flowers is circumpolar, native to the northern regions of America, Canada, Europe, and northern Asia, growing in an amazing diversity of habitats. In addition to rich fens, shrubby cinquefoil occurs in alpine and arctic tundra, dry mountain ridges below as well as above the timberline, and even along the sandy shores of Lake Michigan. There are numerous cultivars of this species found in the horticultural trade.

The genus *Dasiphora* is Greek for "hair bearing," in reference to the leaves that are densely covered with fine silky hairs, especially on the underside. The margins of the leaves fold downward, and the stomata (breathing pores) are located on the underside of the leaves. These appear to be adaptations to help shrubby cinquefoil minimize loss of water through evapotranspiration. The

There is no clearly defined low shrub zone in a fen as there is in a kettlehole sphagnum peat bog. Rather, the most ubiquitous and conspicuous low shrub of the rich fen community is shrubby cinquefoil, which occurs primarily in fen meadows. (Photo by Guy L. Denny.)

Glossy buckthorn (*Frangula alnus*), with its conspicuous glossy leaves, is a nonnative, extremely invasive species often found invading rich fens and sphagnum peat bogs. (Photo by Guy L. Denny.)

specific epithet *fruticosa* is Latin for "shrubby." The common name "cinquefoil" (five leaved) is in reference to the pinnate leaves with usually five narrow elliptic leaflets. In some favorable situations, shrubby cinquefoil populations can become quite dense and can virtually blanket a fen meadow.

Alder-leaved buckthorn (*Rhamnus alnifolia*) is a low-growing, trailing shrub that can occur in the open marl flats as well as in the fen meadow zone. It is a native noninvasive buckthorn that occurs northward through most of the southern half of Canada. It should not be confused with the two nonnative, extremely invasive species of buckthorns, glossy buckthorn (*Frangula alnus*) and common buckthorn (*Rhamnus cathartica*). These two last-mentioned species are very tall, robust shrubs with spine-tipped branchlets. Both pose a serious invasive threat to the ecological integrity of both rich fens and sphagnum peat bogs throughout the southern Great Lakes region.

The following are just a few of the more commonly encountered calciphilic species found growing in most fen meadows, especially those in the southern Great Lakes states. Cowbane (*Oxypolis rigidor*), as its common name implies, has foliage and tuberous roots that are reported to be poisonous to livestock. Starry false Solomon's seal (*Maianthemum stellatum*) is a springtime bloomer that also abundantly grows along the calcareous sandy shores of the Great Lakes. Swamp Thistle (*Cirsium muticum*) is an attractive native thistle that has non-prickly stems and a distinctive flower head that is sticky to the touch. Spotted Phlox (*Phlox maculata*) has distinctive dark purple spots along its stem. Showy coneflower (*Rudbeckia fulgida*) has the general appearance of its close relative black-eyed Susan (*R. hirta*), but mostly occurs in rich fen meadows. Both *Ohio goldenrod* (*Solidago ohioensis*) and *Riddell's goldenrod* (*S. riddellii*)

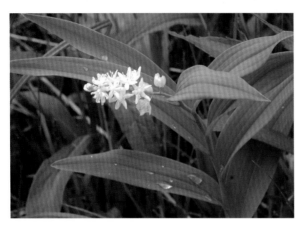

Top left: Cowbane (*Oxypolis rigidior*) commonly occurs in fen meadows of the southern Great Lakes states. This member of the Parsley Family is reported to be poisonous to grazing cattle. (Photo by Guy L. Denny.)

Bottom left: Starry false Solomon's seal (*Maianthemum stellatum*) is a typical species of rich fens, marly flats, and calcareous shores. It has the most attractive flowers and fruits of all of the species of Solomon's seals. (Photo by Guy L. Denny.)

Right: Swamp thistle (*Cirsium muticum*) is one of the most commonly encountered species growing in fen meadows. It is easy to identify because it relatively lacks spines like most thistles, and the calyx is noticeably sticky to the touch. (Photo by Guy L. Denny.)

are unlike most of our other goldenrods in that they are nonaggressive and have a somewhat flat flower head. They are both calciphiles that are very indicative of rich fen communities. Riddell's goldenrod and Ohio goldenrod were first discovered growing in a prairie fen in west-central Ohio by botanist John L. Riddell (1807–1865). Bog goldenrod (*S. uliginosa*) is also a fen-loving calciphile but is distinct from the two previous goldenrods in that its flower head is typically cylindrical in shape and not flat-topped.

At about the same time that the goldenrods are blooming, also blooming will be the very lovely western fringed gentian (*Gentianopsis virgata*), which is also known as the smaller as well as the narrow-leaved fringed gentian. Western fringed gentian is found growing in prairie fens, while its close relative common or eastern fringed gentian (*G. crinita*) tends to occur in fens in addition to a number of other habits based on calcareous wet soils. It can be a challenge even for professional botanists to make a distinction between these two species, which are also known to hybridize and make identification that much more difficult. Generally, the leaves on the main stem, at or just below the lower branches of the western fringed gentian, are linear to linear-lanceolate as compared to those of the eastern fringed gentian, which are ovate to ovate-lanceolate. There is a tendency for the margins of the corolla lobes (the

 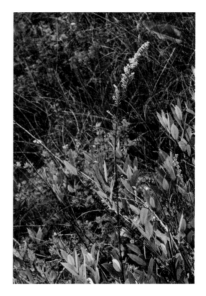

petals, collectively) of the western fringed gentian to be fringed on the sides, but they merely toothed at the apex, as opposed to eastern fringed gentian having the corolla lobes deeply fringed on the sides and apex. However, this difference between the two species doesn't always hold up (Voss 2012).

Spotted Joe-Pye weed (*Eutrochium maculatum*) is easily recognized in fen meadows by its usual red-purple spotted stem and distinctive domed clusters of showy pinkish-purple flowers. There is some question as to whether the name Joe Pye was the name of a Native American medicine man from New England who used this plant to cure colonists of typhus fever, as is frequently reported in botanical publications. In an article appearing in *The Great Lakes Botanist,* researchers Richard B. Pearce and James S. Pringle examined numerous historical documents from the seventeenth century to determine if a Native American medicine man by the name of Joe Pye actually existed (Pearce and Pringle 2017). They learned there was a Mohican named Shauqueathqueat, a member of the Stockport, Massachusetts, Mohicans who was born around 1722. He belonged to a tribe that had been Christianized since about the 1730s. They lived in the Berkshire Hills of western Massachusetts. Shauqueathqueat's given Christian name was Joseph Pye.

According to their research, Joseph Pye became chief of the Stockport Mohicans in 1777. He was held in high esteem by his native people as well as by white settlers in the Stockport community. However, "nothing in Joseph Pye's history suggested he was ever an herbalist let alone a medicine man" (Pearce and Pringle 2017). The naming of Joe-Pye weed and the Joe Pye story apparently originated with Amos Eaton (1776–1842), who taught at Williams College in Williamstown, Massachusetts, which is located about 30 miles north of Stockbridge, the home of Joseph Pye. In Eaton's fourth edition of his

Left: Ohio goldenrod (*Solidago ohioensis*) is a calciphile that is very indicative of rich fen communities, where it can be found growing in the wettest areas of the fen, adjacent to the open marl flats, or within the fen meadow zone. (Photo by Guy L. Denny.)

Center: Riddell's goldenrod (*Solidago riddellii*), a calciphile, is very indicative of the meadows occurring in rich fens. It was first discovered growing in a prairie fen in west-central Ohio by botanist John Riddell in 1835. (Photo by Guy L. Denny.)

Right: Bog goldenrod (*Solidago uliginosa*) is one of the more common species of goldenrods growing in rich fens and other marly wetlands. (Photo by Guy L. Denny.)

Left: Around the same time in late summer when the goldenrods are blooming in the meadow of a rich fen, also blooming will be the western fringed gentian (*Gentianopsis virgata*), also known as the smaller fringed gentian and as the narrow-leaved fringed gentian. (Photo by Guy L. Denny.)

Center: Of the three species of Joe-Pye weeds occurring in the southern Great Lakes region, spotted Joe-Pye weed (*Eutrochium maculatum*) is the species most commonly encountered in rich fen meadows. It is usually easy to distinguish by the red-purple spotting along its main stem. (Photo by Guy L. Denny.)

Right: Several species of ladies'-tresses orchids (*Spiranthes* spp.) occur in the open marl flats and fen meadow communities within rich fens. The common name is thought by most to be in reference to the spiraled arrangement of the flowers of these orchids to a woman's braided hair. (Photo by Guy L. Denny.)

Manual of Botany for the Northern and Middle States, published in 1824, Eaton states, "The two species called joe-pye (from the name of an Indian) are in common use in the western counties of Massachusetts as diaphoretics, etc. in typhus fever" (Eaton, A. 1824). Thereafter, the story of Joe Pye was repeated by numerous authors who embellished the story along the way, creating the folklore about Joe Pye and his use of the plant that bears his name to cure colonists of typhus fever.

Two fairly common orchids to keep an eye out for in the fen meadow zone are the fen twayblade, also called Loesel's twayblade (*Liparis loeselii*) to honor German botanist Johann Loesel, and the much more conspicuous nodding ladies'-tresses orchid (*Spiranthes cernua*). The genus name *Spiranthes* comes from two Greek words meaning "coiled flower," seemingly in reference to the spiraled arrangement of the flowers reminiscent of a woman's braided hair or tresses. Two rarer species of *Spiranthes* also occurring in fens are hooded ladies'-tresses (*S. romanzoffiana*) and Great Plains ladies'-tresses (*S. magnicamporum*). Swamp lousewort (*Pedicularis lanceolata*), purple meadow-rue (*Thalictrum dasycarpum*), winged loosetrife (*Lythrum alatum*), purple-stemmed aster (*Symphyotrichum puniceum*), and (*S. boreale*) are also common components of fen meadows. The most common fern found growing abundantly in this habitat is marsh fern (*Thelypteris palustris*).

Prairie Fens

In addition to the more common fen meadow species listed above, those fen meadows occurring in more western and southern Great Lakes states also typically have a great number of tallgrass prairie species present. These fens are called prairie fens, a term coined by Ohio State University botanist Ronald L.

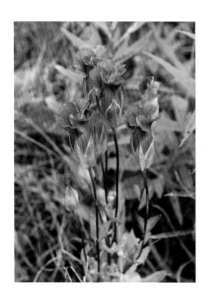

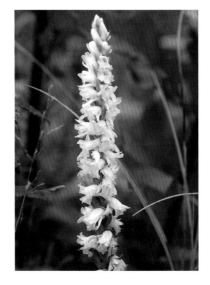

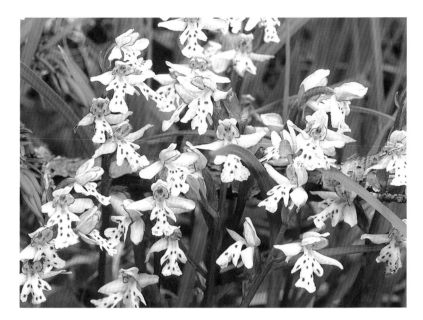

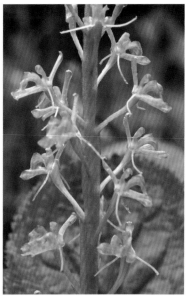

Left: Here is a cluster of spotted round-leaved orchids (*Amreochis rotundifolia*). (Photo by Gary Meszaros.)

Right: Fen orchids (*Liparis loeselii*) occur in fen meadows and wet alkaline seeps. A nondescript species, it is one of many diminutive orchids. (Photo by Gary Meszaros.)

Stuckey (Stuckey 1981). Some of the most common prairie species encountered in prairie fens, even those as far west as Iowa, are tall prairie grasses such as big bluestem (*Andropogon gerardii*) and Indian grass (*Sorghastrum nutans*), along with little bluestem (*Schizachyrium scoparium*) and prairie dropseed (*Sporobolus heterolepis*). Prairie forbs (wildflowers) include such species as prairie dock (*Silphium terebinthinaceum*), whorled rosinweed (*Silphium asteriscus* var. *trifoliatum*), queen-of-the-prairie (*Filipendula rubra*), Indian plantain (*Arnoglossum plantagineum*), gray-headed coneflower (*Ratibida pinnata*), tall coreopsis (*Coreopsis tripteris*), nodding wild onion (*Allium cernuum*), spiked blazing-star (*Liatris spicata*), Virginia mountain mint (*Pycnanthemum virginianum*), rattlesnake-root (*Prenanthes racemosa*), linear-leaved loosestrife (*Lysimachia quadriflora*), common valerian (*Valeriana edulis* var. *ciliata*), and the very rare and beautiful small white lady's-slipper orchid (*Cypripedium candidum*). Rich fens, especially prairie fens, are exceptionally rich in species diversity.

Some find it strange that prairie plants are able to have such a presence in a habitat that is essentially a wetland where roots are typically submersed in water-saturated cold soils. The answer lies in the fact that rich fens are, physiologically speaking, actually drought-prone habitats. The ability of roots submersed in cold, wet soils to absorb water is much reduced. Spring water tends to remain cold, at 50 to 54 degrees Fahrenheit throughout the year, especially at root level. Coldness reduces cellular membrane permeability, alters viscosity of cellular protoplasm, and retards root growth and root hair formation—all of which make it difficult for plants to access water and nutrients. Additionally, directional movement or diffusion of water through root cellular structures by osmosis will typically be from a region of lower solution

Above: Owens Fen/Liberty Fen State Nature Preserve in west-central Ohio's Logan County stands out as an exceptionally fine example of a prairie fen. (Photo by Guy L. Denny.)

Right: Big Bluestem prairie grass (*Andropogon gerardii*), also known as turkey foot grass in reference to the inflorescence that reminds some of the shape of a turkey's foot with its long toes. This grass is one of the main grasses of tallgrass prairies of North America. It is also a frequent component of prairie fens. (Photo by Guy L. Denny.)

concentration to a region of greater solute concentration. The calcium carbonate substrate surrounding roots in a rich fen tend to be at a higher solute concentration than the water in solution within the plant. Calciphiles are well adapted to high calcareous soils, and contain high concentrations of calcium and magnesium carbonate salts. The adaptations that prairie plants have for minimizing loss of water through evapotranspiration, enabling them to do well in drought-prone environments of the tallgrass prairie, explains why they are also equally at home in the physiological drought conditions occurring in open rich fens.

Tall Shrub Zone

In addition to shrubby cinquefoil and alder-leaved buckthorn that are low-growing shrubs, there are a number of tall shrubs characteristic of rich fens, including poison sumac, which is often more abundant in rich fens than in kettle-hole sphagnum peat bogs. Fen shrubs can be randomly scattered throughout the fen meadow or denser toward the perimeter of the fen meadow. Among these shrub species that are characteristic rich fens are a number of rare northern willows, especially in boreal fens. Some of these species range all the way into arctic Canada. They include blueleaf willow (*Salix myricoides*); bog willow (*S. pedicellaris*); shining willow (*S. lucida*); autumn willow (*S. serissima*); beaked willow (*S. bebbiana*), named in honor of botanist M. S. Bebb (1833–1895); and, the easiest to recognize willow of all, hoary willow or sage willow (*S. candida*). with its narrow, dull, silvery-green leaves with rolled-under margins and dense, white, hairy covering. And lastly, there is the abundant and ever-present wetlands generalist, pussy willow (*S. discolor*), which occurs throughout most of the wetlands of eastern North America.

Left: Queen-of-the-prairie (*Filipendula rubra*) is one of the more strikingly beautiful prairie species characteristics of the meadows of prairie fens. (Photo by Guy L. Denny.)

Center: Gray-headed coneflower (*Ratibida pinnata*) is one of the most common prairie wildflowers in the tallgrass prairies of North America. It also occurs in the meadows of most prairie fens. (Photo by Guy L. Denny.)

Right: Nodding wild onion (*Allium cernuum*) is a component of tallgrass prairie ecosystems as well as a common component of prairie fens, where it can be encountered growing in both open marl flat zones and fen meadows. (Photo by Guy L. Denny.)

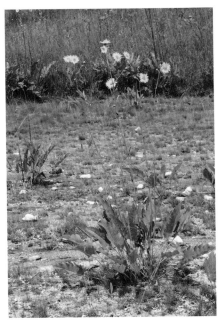

Top left: Spiked blazing star (*Liatris spicata*), also known as marsh blazing star, is a tallgrass prairie species well suited to the sedge meadows of prairie fens, where it frequently occurs and often does so in great numbers. (Photo by Guy L. Denny.)

Top right: Gallagher/ Springfield Fen State Nature Preserve, located in Clark County, Ohio, is a high-quality prairie fen with an unusually large population of cut-leaf prairie dock (*Silphium pinnatifidum*). Prairie dock is a drought-tolerant tallgrass prairie species, but here it grows right in the water-saturated marl openings in a physiological drought substrate where water is not readily accessible to plants. (Photo by Guy L. Denny.)

Below: Most frequently encountered growing in rich fen meadows, rare small white lady's-slipper orchids (*Cypripedium candidum*) are a federally threatened species. (Photo by Gary Meszaros.)

Other tall shrubs of rich fens that tend to be more abundant toward the perimeter of fens, where the graminoid peat layer is much thicker and compacted, include silky dogwood (*Cornus amomum* subsp. *obliqua*), red-osier dogwood (*C. sericea*), nannyberry (*Viburnum lentago*), arrow-wood (*V. dentatum* var. *lucidum*), sweet gale (*Myrica gale*), and winterberry (*Ilex verticillata*), along with ninebark (*Physocarpus opulifolius*). Ninebark is so named for its suppos-

edly nine layers of exfoliating (peeling) bark that peels off in papery strips. Most abundant of all, and frequently occurring in dense thickets, is speckled alder (*Alnus incana* subsp. *rugosa*), so named for the conspicuous speckling of lenticels (small openings on the bark to permit the passage of air) present on the larger main stems and branches. One of the more interesting adaptations that alders and sweet gale have for thriving in nutrient-poor peaty soils is an abundance of nitrogen-fixing root nodules, which enable them to transform atmospheric nitrogen into nitrogen that the plant can utilize.

Blueleaf willow (*Salix myricoides*) is a low-growing, rare northern willow often found growing in rich fens as far south as Ohio. (Photo by Guy L. Denny.)

Shining willow (*Salix lucida*) is one of the more common willows occurring in rich fens within the southern Great Lakes region. As its name implies, it has conspicuously shiny leaves. (Photo by Guy L. Denny.)

Boreal Rich Fens

Boreal fens tend to be more northern in their distribution than prairie fens. However, they also can occur as far south as northeast Illinois, the southern half of Michigan, and the northern halves of Indiana and Ohio. Boreal rich fens have a larger number of more northern or boreal species present. The term boreal fens was coined by Pleistocene geologist Jane Forsyth in reference to Ohio's Cedar Bog (Forsyth 1974). Cedar Bog is located in the west-central

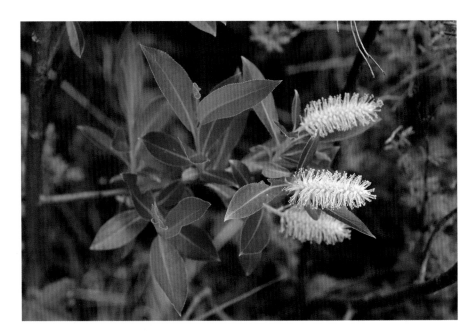

Autumn willow (*Salix serissima*) often occurs in rich fens. (Photo by Guy L. Denny.)

Hoary or sage willow (*Salix candida*) is one of the easiest willows to identify when encountered growing in rich fens. Unlike all other willows one might find growing in a boreal rich fen, this species has a hoary whitish-gray overall appearance with its narrow, dull, silver-green leaves with rolled-under margins and dense, white hairy coating. (Photo by Guy L. Denny.)

part of the state and is interesting because it is the largest and most floristically diverse rich fen occurring in Ohio. What is most fascinating about Cedar Bog is that it is an outstanding and very distinct example of a combination of both prairie fen and boreal rich fen. It is the southernmost known boreal fen in the Great Lakes region. The open marl community and fen meadow, which support a large number of range-disjunct northern species, is surrounded by a large grove of northern white cedar (*Thuja occidentalis*).

The next closest such boreal fen containing northern white cedars is about 200 miles to the north in central Michigan. Ohio's Cedar Bog is all that is left of a white cedar boreal fen community that once covered about 7,000 acres of the Mad River Valley. By 1912, most of this fen was reduced to about 600 acres as a result of cutting, draining, and burning to open the way for agriculture (Dachnowski 1912). Today, only 190 acres remain as a protected state nature preserve that is owned by the Ohio History Connection and the Ohio Department of Natural Resource's Division of Natural Areas and Preserves, and is managed by the Cedar Bog Association. In addition to northern white cedar, another disjunct Canadian species thriving in Cedar Bog State Nature Preserve, is dwarf birch (*Betula pumila*). This shrubby species ranges from Newfoundland and Ontario south to Ohio and Indiana, which are the southernmost occurrences of this species in North America. Perhaps the rarest orchid found in Cedar Bog State Nature Preserve is the small yellow lady's-slipper (*Cypripedium parviflorum* var. *makasin*), with its thumb-sized, yellow lady's-slipper pouch and distinctive dark, purple-brown, twisted sepals.

In contrast to west-central Ohio's Cedar Bog State Nature Preserve, the boreal fens of northeastern Ohio are different from their more southern counterparts, which tend to be prairie fens. Generally, rich fens occurring in more northern latitudes have a larger number of northern or boreal species present, including species of *Sphagnum* moss. As

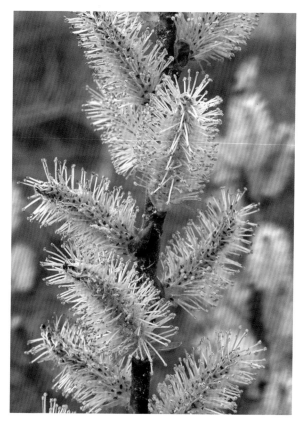

Bright pussy willow catkins (*Salix discolor*) adorn wet areas in early spring. (Photo by Gary Meszaros.)

Speckled alder (*Alnus incana*) occurs as a common tall shrub around kettlehole sphagnum peat bogs as well around the perimeter of rich fens. (Photo by Guy L. Denny.)

graminoid peat accumulates in boreal fens, especially leaf litter from shrubby cinquefoil, certain species of *Sphagnum* can become established around the base of shrubby cinquefoil, forming hummocks of *Sphagnum* moss. These species of mosses, which are more tolerant of nutrient-rich sites, include red-green peat moss (*Sphagnum warnstorfii*), cow-horn peat moss (*S. subsecundum*), and teres peat moss (*S. teres*). This is where both large and small cranberries can become established along with round-leaved sundew and, at least in one such Ohio fen, even *Arethusa* orchids can take root. Sphagnum hummocks can eventually join with other sphagnum hummocks, producing a covering of *Sphagnum* moss over the fen meadow that blankets the graminoid peat and makes the site look more like a sphagnum peat bog. Nevertheless, it primarily continues to be a rich fen with calciphiles, such as grass-of-Parnassus rooted in marl right next to acidophiles (plants adapted to an acidic environment), like large cranberry, that are rooted in the sphagnum moss hummock overlying the marl in which the grass-of-Parnassus is rooted. It can be a fascinating assemblage of both rich fen as well as acid-loving bog plants growing side by side.

Where the flow of calcareous groundwater is strong enough to flush away peat deposits, open marl flats with their full complement of rich fen plants persist. In open marl flats in boreal fens, one finds an abundance of more

Here we see the high-quality open marl flats of Cedar Bog State Nature Preserve in Champaign County in west-central Ohio. Cedar Bog is actually the largest and most biologically diverse rich fens in Ohio. (Photo by Guy L. Denny.)

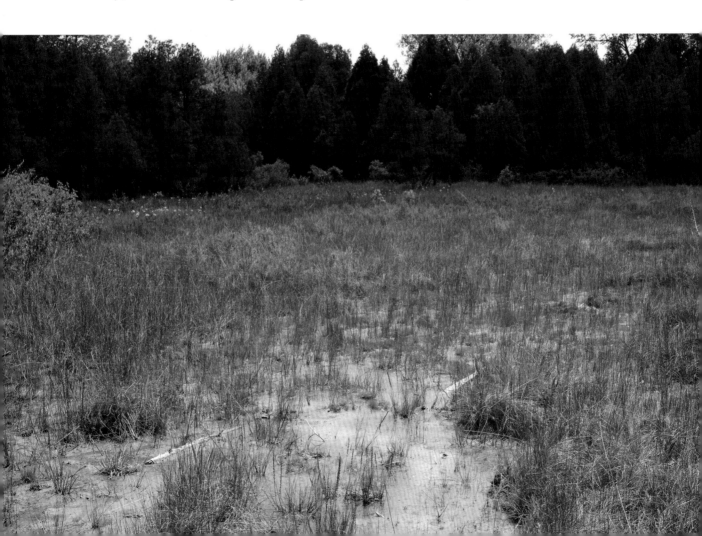

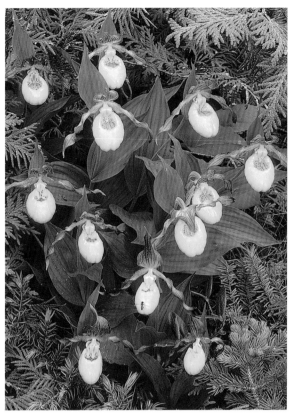

northern-ranging plants, including *Canadian burnet* (*Sanguisorba canadensis*), calopogon and rose pogonia orchids, green-keeled cotton grass, Kalm's lobelia, grass-of-Parnassus, twig-rush, white-beaked rush, northern pitcher plant, round-leaved sundew, Ohio goldenrod, Riddell's goldenrod, white camas, false asphodel, and the extremely lovely and rare showy lady's-slipper orchid (*Cypripedium reginae*). Neither showy lady's-slipper orchids nor yellow lady's-slipper orchids (*C. parviflorum*) are rare in more northern rich fens in the upper Great Lakes region. Although northern white cedar does not occur today in northeastern Ohio's boreal fens, tamarack does occupy some of the more northern fen meadows, along with an abundance of shrubby cinquefoil, alder-leaved buckthorn, silky dogwood, hoary willow, and dwarf birch.

The Outside Fen Perimeter

Rich fens, just like kettlehole sphagnum peat bogs, are subject to natural plant succession and will eventually disappear from our landscape—a landscape that is outside their boreal forest natural range. Eventually, a thick blanket of graminoid peat overtops the marl openings and thickens beneath the fen meadow.

Left: Dwarf birch (*Betula pumila*)is a shrubby species of birch that ranges from Newfoundland and Ontario south to Ohio and Indiana, which are the southernmost occurrences of this species in North America. (Photo by Guy L. Denny.)

Right: These very rare, small yellow lady's-slipper orchids (*Cypripedium parviflorum* var. *makasin*) are growing in a cedar fen. They occur infrequently in rich fens. (Photo by Gary Meszaros.)

Overleaf: A spring-fed stream flows through a sedge meadow at Cedar Bog State Nature Preserve in Champaign County, Ohio. Actually a rich fen, it is one of Ohio's finest natural areas. (Photo by Gary Meszaros.)

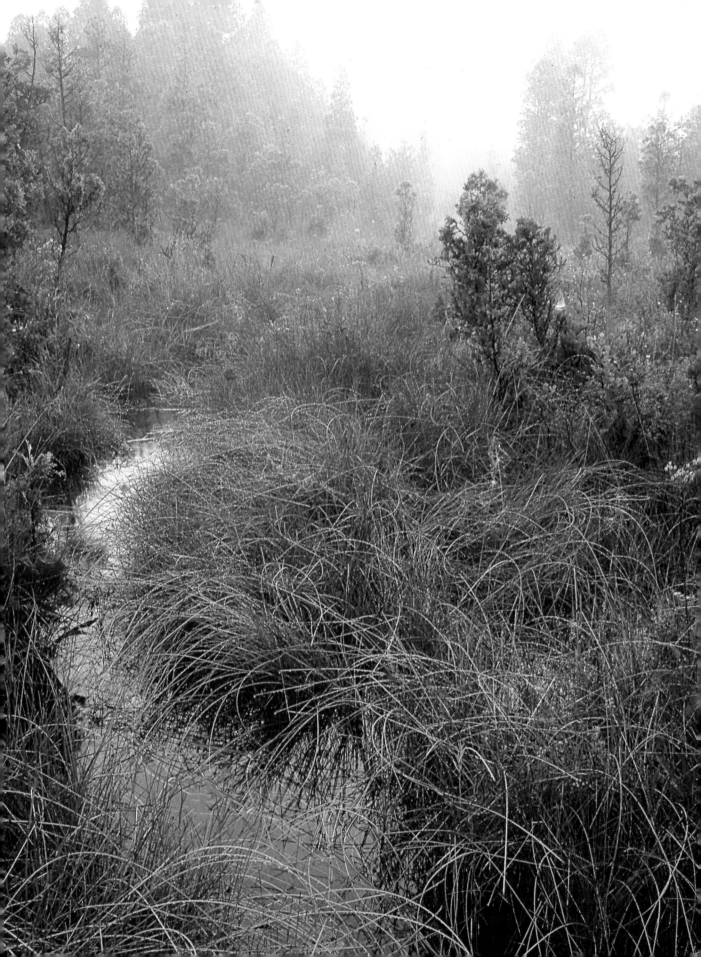

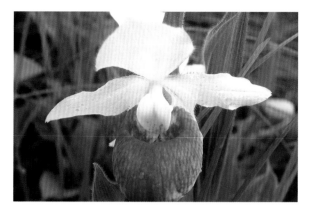

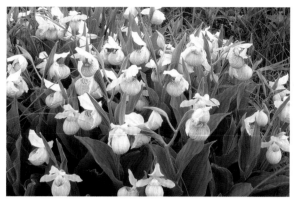

Left and right: White sepals are in striking contrast to the rose-mouthed pouch of the showy lady's-slipper orchid (*Cyripedium reginae*). (Photos by Gary Meszaros.)

This blanket of insulation dramatically reduces the impact of flowing alkaline waters responsible for providing the special environmental conditions that enable boreal species to persist ever since the last ice age. As this happens, fen communities are lost and replaced by marsh and swamp forest communities characteristic of these more southern latitudes. Often the process starts with the invasion of tussock sedge (*Carex stricta*), which then transitions into fields of Canada bluejoint grass (*Calamagrostis canadensis*), rice cut grass (*Leersia oryzoides*) with its sharp-edged blades capable of cutting skin as one walks through it, and then other wetland grasses and semi-wetland plants. These other plants include swamp milkweed (*Asclepias incarnata*), blue vervain (*Verbena hastata*), white turtlehead (*Chelone glabra*), and boneset (*Eupatorium perfoliatum*). Eventually, semi-wetland shrubs like common elderberry (*Sambucus canadensis*), red-osier dogwood (*Cornus sericea*), and swamp rose (*Rosa palustris*), along with swamp forest species of trees, will replace and mask all traces of the fen community. Only the presence of well-concealed muck soils underlain with marl will reveal that a fen ever existed on that site.

Other Northern Fen Communities

Without going into the complexities of boreal peatlands in northern Minnesota and northern Wisconsin, let's take a quick look at patterned fens

White wands of Canadian burnet (*Sanguisorba canadensis*) bloom along with spotted Joe-Pye weed (*Euthochium maculatum*) in a poor fen meadow in summer. (Photo by Gary Meszaros.)

or aapamires, as peatland ecologists call them. These fens are fairly common landscape features of the Red Lakes region of northern Minnesota and throughout much of Canada. Observing from a small airplane while flying over those fens in Minnesota, these patterned peatlands are very impressive,

Right: For a few weeks in June, Baltimore checkerspots (*Euphydryas phaeton*) emerge to mate and lay eggs for the following generation. The larva feed on the turtlehead plant in a communal web until autumn. (Photo by Gary Meszaros.)

Below: The rich fens in northern latitudes often have many of the same species as their southern Great Lakes region boreal fen counterparts, but they might look quite different overall, like Shingleton bog, pictured here, which is actually an extensive rich fen in the Upper Peninsula of Michigan. (Photo by Guy L. Denny.)

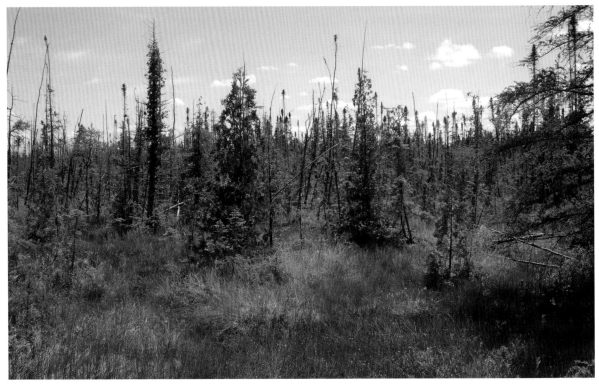

are distinctively patterned, and cover many square miles. The closest ones to the southern Great Lakes region are in the Upper Peninsula of Michigan, including Seney National Wildlife Refuge. These form on slight, almost imperceptible slopes over which there is a gentle flow of mineral-rich ground water. They are called patterned fens because the flow of water typically creates a ladderlike pattern of long linear ridges of peat known as strings, alternating with long linear pools known as flarks. The strings tend to have fen vegetation approaching the peaty meadows of southern fens, while the flarks tend to support fen vegetation somewhat characteristic of open marl flats or marl meadow openings. Many of the characteristic fen species listed for rich fens, as well as poor fens, occur in these aapamires or patterned fens.

Another type of rich fen community is known as a coastal fen, and it occurs along the shorelines of primarily Lake Michigan and Lake Huron. These communities typically occur in protected coves where underground seeps and springs rich in calcium and magnesium carbonates emerge from adjacent uplands, forming fen meadows and marl

Above and below: Classic examples of rich white cedar fens can be seen at Canada's Bruce Peninsula. (Photos by Gary Meszaros.)

openings grading into alkaline sands and clays along the lakeshore. Floristically, these fens are similar to the rich boreal fens occurring farther inland away from the shores of the Great Lakes.

Finally, although not technically called fens, communities of largely rich fen plants occur in what are known as pannes. Pannes occur along the extensive, wide, sandy shorelines of the Great Lakes, especially along the north shores of Lake Michigan. They are mostly somewhat narrow, shallow, and linear interdunel wet depressions supporting a floristic community of mostly rich fen species. Their source of alkaline water generally does not come directly from flowing underground springs but rather from alkaline lake waters moving through beach sands from the open lake shoreward. It is easy to understand how rich fen species flourish in these shallow interdunel pools, considering that the waters of the Great Lakes tend to be very alkaline. For example, the waters of Lake Michigan have a pH of around 8.0.

Peatlands Wildlife

Peatlands in more northern latitudes within the southern Great Lakes region support a number of species of wildlife, including nesting birds such as palm warblers (*Dendroica palmarum*), which often nest in *Sphagnum* moss hummocks. Then there are also Lincoln's sparrows (*Melospiza lincolnii*), olive-sided flycatchers (*Contopus cooperi*), and yellow-bellied flycatchers (*Empidonax flaviventris*)—all of which nest in bog shrubs. Sandhill cranes (*Antigone canadensis*) frequently nest in rich fen sedge meadows. Farther south, where kettlehole bogs and rich fens are at their southernmost limits, they are too small and disjunct from one another to support a great diversity of wildlife that are solely dependent on these specialized peatland habitats. As one might expect, because kettlehole sphagnum peat bogs and rich fens are wetlands, there we often encounter wildlife species normally associated with wetlands, such as raccoons (*Procyon lotor*), mink (*Mustela vison*), opossums (*Didelphis marsupialis*), small rodents, painted turtles (*Chrysemys picta*), common snapping turtles (*Chelydra serpentine*), green frogs (*Lithobates clamitans*), eastern American toads (*Anaxyrus americanus*), northern ribbon snakes (*Thamnophis sauritus septentrionalis*), common garter snakes (*Thamnophis sirtalis*), and northern water snakes (*Nerodia sipedon*).

The waters of kettlehole sphagnum peat bogs are too acidic for most amphibians, with two notable exceptions in the southern Great Lakes region: wood frogs (*Lithobates sylvaticus*) and four-toed salamanders (*Hemidactylium scutatum*). These two amphibians are tolerant of pH levels down to 4.0 (Johnson 1985). Actually, these species are more often encountered in the swamp forest and lagg zones of kettlehole peat bogs than on the sphagnum mat. The wood frog is a medium-sized brownish to sometimes grayish frog with a distinctive dark mask. It ranges throughout Canada to beyond the Arctic Circle,

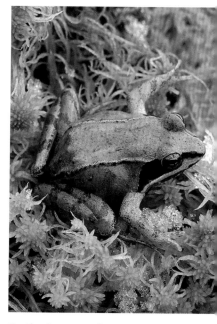

Peatlands are usually too acidic for most frog species except the wood frog (*Lithobates sylvaticus*). In early spring, their tennis ball–sized egg masses can be seen in shallow woodland ponds. (Photo by Gary Meszaros.)

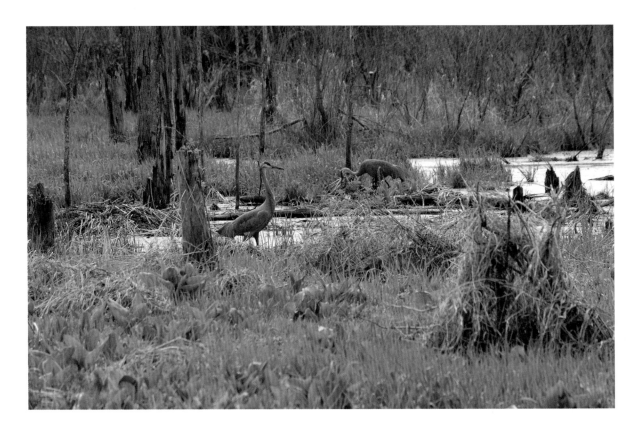

Sandhill cranes (*Antigone canadensis*) are mostly northern-ranging birds that favor shallow water sedge meadows of northern rich fens for nesting. (Photo by Guy L. Denny.)

farther north than any other American amphibian. Except for during the short early-spring breeding season, a wood frog spends most of its time on land in woodlands some distance from water. It is one of the few amphibians that is not only unaffected by the acidity of sphagnum peat bog water, but also one of a very few cold-adapted boreal amphibians that can overwinter within the frost zone. Special body fluids work somewhat as a natural antifreeze to protect its cells and organs from freezing during the winter months.

The four-toed salamander, like the wood frog, is not restricted to peatlands but is often encountered in peatland habitats. The four-toed is the smallest salamander and has only four toes on its hind feet (other salamanders have five toes on both front and hind feet). Its most distinguishing feature is its bright white belly with black spots. This is a very secretive salamander that spends most of its time on land hiding under clumps of moss, dead leaves, and decaying pieces of wood. In bogs, the four-toed salamander can be encountered within mossy hummocks. It ranges from Nova Scotia, west across the Great Lakes region to eastern Minnesota, and then south to the Florida panhandle.

When blueberries, huckleberries, and other wild fruits are ripe and ready for picking, a great number of birds will flock to kettlehole sphagnum peat bogs for the harvest. Among these are cedar waxwing (*Bombycilla cedrorum*), American robin (*Turdus migratorius*), gray catbird (*Dumetella carolinensis*),

veery (*Catharus fuscescens*), Hermit thrush (*Catharus guttatus*), and wood thrush (*Hylocichla mustelina*). A number of wetland generalists, such as yellow warbler (*Dendroica petechial*), common yellowthroat (*Geothlypis trichaas*), and *red-winged blackbird* (*Agelaius phoeniceus*), will frequent and nest within or in close proximity to peatlands. However, peatlands are just one of many wetland habitats to which they are attracted.

Although kettlehole sphagnum peat bogs are too acidic and low in oxygen to support most species of fish, large alkaline kettlehole lakes and the larger, faster-moving nutrient-rich streams in rich fens can support a number of rare

Sphagnum woods and boggy ponds are habitats for the four-toed salamander (*Hemidactylium scutatum*). Females with eggs can be found under clumps of sphagnum moss near open water. (Photo by Gary Meszaros.)

A four-toed salamander (*Hemidac-tylium scutatum*) rests in sphagnum moss. Sphagnum moss has very large leaf and branch cells that enable it to store large quantities of water. (Photo by Gary Meszaros.)

The flutelike call of the hermit thrush (*Catharus guttatus*) can be heard during spring and summer in coniferous and mixed woodlands. (Photo by Gary Meszaros.)

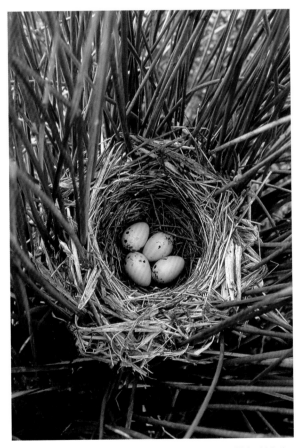

Abundant and aggressive colonies of red-winged blackbirds (*Agelaius phoeniceus*) nest in all types of wetlands. Blue, lightly marked eggs are concealed in dense vegetation. (Photo by Gary Meszaros.)

species adapted to cold, highly alkaline waters. Alkaline lakes can support such rare small fish as Iowa darters (*Etheostoma exile*), least darters (*E. microperca*), and lake chubsuckers (*Erimyzon sucetta*). Flowing streams within rich fens typically support populations of such rarities as western banded killifish (*Fundulus diaphanous menona*), brook sticklebacks (*Culaea inconstans*), central mud minnows (*Umbra limi*), southern redbelly dace (*Chrosomus erythrogasteer*), and northern mottled sculpins (*Cottus bairdii bairdii*).

Kettlehole sphagnum peat bogs and rich fens in the southern Great Lakes region support a number of mostly common dragonflies. However, there are a few rare exceptions, including the more northern-ranging chalk-fronted corporal (*Ladona julia*), elfin skimmer (*Nannothemis bella*), and both the American emerald (*Cordulia shurtleffi*) and racket-tailed emerald (*Dorocordulia libera*) dragonflies. Rich fens are prime habitat for such more northern species as the seepage dancer damselfly (*Argia bipunctulata*), eastern red damsel (*Amphiagrion saucium*), and, perhaps even better habitat than kettlehole sphagnum bogs, for the elfin skimmer dragonfly (*Nannothemis bella*), which is the smallest of dragonfly in North America (Rosche 2008).

Two rare reptiles associated with sphagnum peat bogs and rich fens in Ohio and adjacent states are the spotted turtle (*Clemmys guttata*) and the eastern massasauga rattlesnake (*Sistrurus catenatus catenatus*). The spotted turtle is a very handsome little turtle with a black upper shell normally covered with bright yellow spots. It can be found inhabiting kettlehole sphagnum peat bogs, but it is far more commonly encountered in the flowing streams and deeper pools of rich fens. Unlike most other species of aquatic turtles, the spotted turtle is very tolerant of low water temperatures, making it quite at home in the cool waters of rich fens. On cold but sunny days in early spring, it can often be seen basking on logs and hummocks long before most other turtles have emerged from hibernation.

Top left: Local populations of western banded killfish (*Fundulus diaphanous menona*) are found in clear glacial ponds and lakes with an abundance of aquatic vegetation. (Photo by Gary Meszaros.)

Top right: Iowa darters (*Etheostoma exile*) are restricted to clear glacial lakes. Excessive runoff from pollution has eliminated many populations. (Photo by Gary Meszaros.)

Above left: Central mudminnows (*Umbra limi*) use their pectoral fins to climb through dense aquatic vegetation. Thanks to a vascularized swim bladder, they can survive in oxygen-depleted water, including bogs. (Photo by Gary Meszaros.)

Above right: The American Emerald (*Cordulia shurtleffi*) is a large dragonfly with conspicuous green eyes. This is a common northern species that has shown up at the southernmost edge of its range at Triangle Lake Bog State Nature Preserve in Portage County, Ohio. This species is listed as a state endangered in Ohio. (Photo by Guy L. Denny.)

Left: Rich fens are prime habitats for seepage dancers (*Argia bipunctulata*), a northern species. This damselfly is very rare as far south as Ohio. Populations still can be encountered in Cedar Bog State Nature Preserve (actually a fen) and Prairie Road Fen State Nature Preserve in west-central Ohio. (Photo by Guy L. Denny.)

Bottom: The common baskettail (*Epitheca cynosura*) is one of the most abundant odonate species in northern wetlands. These small dragonflies course back and forth in open areas along the forest edge. (Photo by Gary Meszaros.)

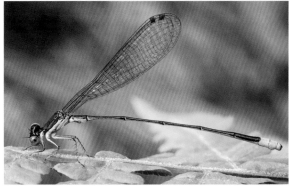

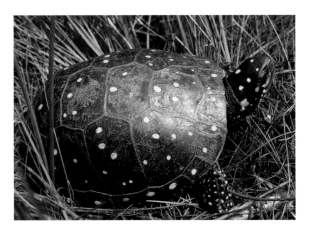

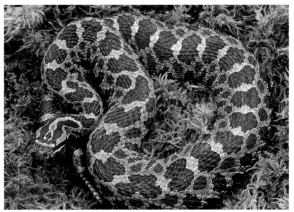

Top left: Similar to sphagnum sprites, sedge sprites (*Nehalennia irene*)—seen here in a close-up— are less habitat specific and are found in many types of wetlands. (Photo by Gary Meszaros.)

Top right: As the name implies, inch-long sphagnum sprites (*Nehalennia gracilis*) inhabit sphagnum peatlands. This close-up of a tiny damselfly shows how it hovers among bog plants, which include sphagnum moss, sedges, and cranberry. (Photo by Gary Meszaros.)

Above left: Spotted turtles (*Clemmys guttata*) are strongly associated with kettlehole sphagnum peat bogs and rich fens in Ohio and adjacent states within the southern Great Lakes region. Although they can be encountered inhabiting kettlehole sphagnum peat bogs, they are far more commonly encountered in the flowing streams and deeper pools of rich fens. (Photo by Guy L. Denny.)

Above right: Swamp rattler or black snapper are two common names given to the eastern massasauga (*Sistrurus catenatus*). Wet prairie fens and bogs are preferred habitats for the uncommon species. (Photo by Gary Meszaros.)

With the arrival of hot late-summer days, it disappears to seek shelter beneath the cold substrates of bogs and fens for months on end.

The eastern massasauga is a small secretive rattlesnake that is a typical inhabitant of high-quality, expansive rich fen meadows. The name *massasauga* is a Chippewa name meaning "great river mouth." This well-camouflaged snake with its earth-toned color pattern tends to avoid being seen as its first line of defense. If threatened, it rattles a high-pitched but soft buzz. Most are reluctant to strike unless thoroughly aroused by being stepped on or seized, but a few can be more aggressive, as personally experienced in Bergen Byron Swamp, which is a northern white cedar–dominated boreal rich fen southwest of Rochester, New York. Nevertheless, the bite is seldom if ever fatal to a healthy adult because the venom, although highly toxic, is not injected deeply by the snake's small fangs,

which are so small that they often fail to penetrate footwear or even loose-fitting trousers. However, that is not to say the bite is not extremely painful and serious. These rare little snakes are a symbol of wild, undisturbed peatlands, and they offer little danger to humans willing to admire them from a distance and otherwise leave them alone.

The Future of Our Peatlands

Bogs and rich fens of the southern Great Lakes region are precious living relics of the last ice age. Even though they have survived within our landscape for the last 10,000 to 20,000 years, they, just like all ecosystems, are not permanent. Natural succession, including lake-filling of glacial depressions and peat blanketing over rich fens, will displace rare northern species with marsh and ultimately swamp-forest vegetation more typical of these southerly latitudes.

A great many peatlands have already been lost to natural succession, draining, cutting, grazing, and burning to open up land for agriculture and other development. Today, perhaps the greatest and most immediate threat to bogs and fens of the southern Great Lakes region is from nonnative invasive species, such as glossy buckthorn (*Frangula alnus*), European buckthorn (*Rhamnus cathartica*), purple loosestrife (*Lythrum salicaria*), common reed (*Phragmites australis*), and reed canary grass (*Phalaris arundinacea*), just to mention some of the most serious nonnative wetland invaders. While most of our problem invasive species are nonnative, resource land managers sometimes have to battle especially aggressive native ones as well. Some examples are speckled alder (*Alnus incana*), poison sumac (*Toxicodendron vernix*), pussy willow (*Salix discolor*), red-osier dogwood (*Cornus sericea*), and red maple (*Acer rubrum*). They, too, can crowd out rarer disjunct northern plants and boreal ecosystems.

It is good that some of our best remaining kettlehole sphagnum peat bogs and rich fens are in state and federal ownership as well as in private ownership, such as with the Nature Conservancy and private land trusts. However, there is an ongoing and never-ending effort to control and eliminate invasive species before these aggressive invaders crowd and shade out rare boreal peatland species as well as disrupt and threaten the continued existence of peatland ecosystems.

Fortunately, humans no longer look at peatlands as dark, scary places inhabited by threatening ghostly spirts and dreadful imaginary wild beasts. Rather, most view peatlands as splendid natural ecosystems fashioned not by the hand of man but by wondrous, ancient natural processes. Kettlehole sphagnum peat bogs and rich fens are fun places to explore, discover new things, and observe the wonders of the natural world—a world full of exciting and amazing discoveries and great natural beauty. Most geologists believe that the Ice Age has not ended. Instead, they believe we are just enjoying one of those prolonged warm interglacial periods, and sometime during the next 100,000 years or so, another major glaciation will be on its way. If that is the case, the next continental glacier will once again erase all vegetation on our current landscape and start things all over again. In the meantime, it is up to us to protect and savor our natural areas for as long as we can for the benefit and enjoyment of this for current and future generations. Once these wonderful natural features are gone, it will take hundreds of thousands of years before they can be replaced by the next ice age continental glacier to make an appearance, and that is a very long time to humans to wait.

Bibliography

Anderson, Dennis S., and Ronald B. Davis. "The Vegetation and Its Environment in Maine Peatlands." *Canadian Journal of Botany* 75 (1997): 1785–805.

Anderson, M. Kate. *Plant Guide for Bog Labrador Tea (Ledum groenlandicum).* Greensboro, NC: USDA-Natural Resources Conservation Services, National Plant Team, 2011.

Anderson, W. A. "A Fen in Northwestern Iowa." *American Midland Naturalist* 29, no. 3 (1943): 787–91.

Andreas, Barbara K. "The Flora of Portage, Stark, Summit and Wayne Counties, Ohio." PhD diss., Kent State University, 1980.

Andreas, Barbara K., and Jeff D. Knoop. "Fens and Bogs of Northeastern Ohio." Unpublished article, 1987.

———. "100 Years of Changes in Ohio Peatlands." *Ohio Journal of Science* 92 (1992): 130–38.

Andrus, Richard E. "Some Aspects of *Sphagnum* Ecology." *Canadian Journal of Botany* 64 (1986): 3128–39.

———. "*Sphagnaceae* (Peat Moss Family) of New York State," Bulletin 442. Albany, NY: New York State Museum, 1980.

Andrus, Richard E., D. J. Wagner, and J. E. Titus. "Vertical Zonation of *Sphagnum* Mosses along Hummock-hollow Gradients." *Canadian Journal of Botany* 61 (1983): 3128–39.

Angier, Bradford. *Field Guide to Edible Wild Plants.* Harrisburg, PA: Stackpole Books, 1982.

Bennett, Dean B. *Maine's Natural Heritage: Rare Species and Unique Natural Features.* Camden, ME: Down East Books, 1988.

Billings, William D., and Harold A. Mooney. "The Ecology of Arctic and Alpine Plants." *Biological Reviews* 43 (1968): 481–530.

Black, Merel R., and Emmet J. Judziewicz. *Wildflowers of Wisconsin and the Great Lakes Region.* 2nd ed. Madison: Univ. of Wisconsin Press, 2009.

Brandenburg, David M. *National Wildlife Federation Field Guide to Wildflowers of North America.* New York: Sterling Publishing, 2010.

Braun, E. Lucy. *The Monocotyledoneae: Cat-tails to Orchids.* Columbus: Ohio State Univ. Press, 1967.

———. *The Woody Plants of Ohio: Trees, Shrubs, and Woody Climbers Native, Naturalized, and Escaped.* Columbus: Ohio State Univ. Press, 1961.

Bryan, Guara R., and Barbara K. Andreas. *Chemical and Physical Characteristics of Ground Waters in Eight Northeastern Ohio Peatlands.* Columbus: Ohio Department of Natural Resources, Division of Natural Areas and Preserves, 1986.

Caljouw, C. A. *The Great Heath: A Natural Areas Description.* Augusta: Executive Department, Bureau of Public Lands and Maine State Planning Office, 1982.

Camp, Mark J. *Roadside Geology of Ohio.* Missoula, MT: Mountain Press, 2006.

Chadde, Steve W. *A Great Lakes Wetland Flora.* Calumet, MI: Pocketflora Press, 1998.

Chapman, W. K., and A. E. Bessette. *Trees and Shrubs of the Adirondacks: A Field Guide.* New York: North Country Books, 1990.

Cohen, Joshua G., Michael A. Kost, Bradford S. Slaughter, and Dennis A. Albert. *A Field Guide to the Natural Communities of Michigan.* East Lansing: Michigan State Univ. Press, 2015.

Collingwood, G. H., and Warren D. Brush. *Knowing Your Trees.* Washington, DC: American Forestry Association, 1974.

Cooperrider, Tom S., and Allison W. Cusick. *Seventh Catalogue of the Vascular Plants of Ohio.* Columbus: Ohio State Univ. Press, 2001.

Craigie, J. S., and W. S. G. Maass. "The Cation-exchange in *Sphagnum* spp." *Annals of Botany* 30 (1966): 153–54.

Crum, Howard. *A Focus on Peatlands and Peat Mosses.* Ann Arbor: Univ. of Michigan Press, 1991.

Curtis, John T. "Fen, Meadow, and Bog." In *The Vegetation of Wisconsin,* 361–84. Madison: Univ. of Wisconsin Press, 1959.

Dachnowski, Alfred. P. "Peat Deposits in Ohio: Their Origin, Formation, and Uses." In *Geological Survey Series 4, Bull. No. 16.* Columbus: Ohio Department of Natural Resources, 1912.

Davis, Ronald B. *Bogs and Fens: A Guide to the Peatland Plants of the Northeastern Unit United States and Adjacent Canada.* Hanover, NH: Univ. Press of New England, 2016.

Davis, Ronald B., and Dennis S. Anderson. "The Eccentric Bogs of Maine." In *Maine Agricultural Experiment Station, Technical Bulletin 146.* Orono: Univ. of Maine, 1991.

Denny, Guy L. "Bogs." In *Ohio Natural Heritage,* edited by Michael B. Lafferty, 141–50. Dublin: Ohio Academy of Science, 1979.

Denny, Guy L. *Directory of Ohio's State Nature Preserves.* Columbus: Ohio Department of Natural Resources, Division of Natural Areas and Preserves, 1996.

Eastman, John. *The Book of Swamp and Bog: Trees, Shrubs, and Wildflowers of Eastern Freshwater Wetlands.* Mechanicsburg, PA: Stackpole Books, 1995.

Eaton, Amos. *A Manual of Botany for the Northern and Middle States of America.* 2nd ed. Albany, NY: Websters and Skinners, 1818.

———. *A Manual of Botany, for the Northern and Middle States of America.* 4th ed. Albany, NY: Websters and Skinners, 1824.

Erichsen-Brown, Charlotte. *Medicinal and Other Uses of North American Plants: A Historical Survey with Special Reference to the Eastern Indian Tribes.* Mineola, NY: Dover Publications, 1979.

Fernald, Merritt Lyndon. *Gray's Manual of Botany.* 8th ed. New York: Van Nostrand Reinhold, 1970.

Foos, Karen A. "A Floristic and Phytogeographic Analysis of the Fen Element at the Resthaven Wildlife Area (Castalia Prairie), Erie County, Ohio." MS thesis, Ohio State University, 1971.

Forsyth, Jane L. "Age of the Buried Soils in the Sandusky, Ohio Area." *American Journal of Science* 265 (1965): 571–97.

———. "Geologic Conditions Essential for the Perpetuation of Cedar Bog, Champaign, County Ohio." *Ohio Journal of Science* 74, no. 2 (1974): 116–25.

———. "Ice Age Census." *Ohio Conservation Bulletin* 27, no. 9 (1963): 16–19, 31, back cover.

Foster, Steven, and Jim A. Duke. *A Field Guide to Medicinal Plants and Herbs of Eastern and Central North America.* 2nd ed. New York: Houghton Mifflin, 2000.

Glaser, Paul H. "The Ecology of Patterned Boreal Peatlands of Northern Minnesota: A Community Profile." *U.S. Fish and Wildlife Service Biological Report* 85, no. 7.14 (1987).

Gleason, Henry Allen, and Arthur Cronquist. *Manual of Vascular Plants of the Northeastern United States and Adjacent Canada,* 2nd ed. Bronx, NY: New York Botanical Garden, 1991.

Glen, Hugh. *Sappi What's in a Name?* Johannesburg, South Africa: Jacana Media, 2004.

Glime, Janice M. *The Elfin World of Mosses and Liverworts of Michigan's Upper Peninsula and Isle Royale.* Houghton, MI: Isle Royale Natural History Association, 1993.

Glob, Peter V. *The Bog People: Iron Age Man Preserved.* Ithaca, NY: Cornell Univ. Press, 1970.

Goldthwait, Richard P. "Ice over Ohio." In *Ohio Natural Heritage,* edited by Michael B. Lafferty, 32–47. Dublin: Ohio Academy of Science, 1979.

———. "Scenes in Ohio during the Last Ice Age." *Ohio Journal of Science* 59 (1959): 193–216.

Gordon, Robert B. "A Unique Raised Bog at Urbana, Ohio." *Ohio Journal of Science* 33 (1933): 453–59.

Grimm, William Carey. *The Book of Shrubs.* Harrisburg, PA: Bonanza Books, 1957.

Gunther, E. *Ethnobotany of Western Washington: The Knowledge and Uses of Indigenous Plants by Native Americans.* Seattle: Univ. of Washington Press, 1973.

Hansen, Michael C. *The Ice Age Ohio,* Educational Leaflet no. 7, rev. ed. Columbus: Ohio Department of Natural Resources, Division of Geological Survey, 2008.

Harding, James H. *Amphibians and Reptiles of the Great Lakes Region.* Ann Arbor: Univ. of Michigan Press, 1997.

Harlow, William M. *Trees of Eastern and Central United States and Canada.* New York: Dover Publications, 1957,.

Harlow, William M., and Ellwood S. Harrar. *Textbook of Dendrology.* New York: McGraw-Hill, 1969.

Hays, James D., John Imbrie, and Nicholas J. Shackleton. "Variations in the Earth's Orbit: Pacemaker of the Ice Ages." *Science* 194, no. 4270 (1976): 1121–32.

Hedrick, Ulysses P. *Sturtevant's Edible Plants of the World.* New York: Dover Publications, 1972.

Hoagman, Walter J. *A Field Guide: Great Lakes Coastal Plants.* Lancing: Michigan Department of Natural Resources, 1994.

Homoya, Michael A. *Orchids of Indiana.* Bloomington: Indiana Univ. Press, 1993.

Jackson, Marion T., ed. *The Natural Heritage of Indiana.* Blooming: Indiana Univ. Press, 1997.

Jaeger, Edmund C. *A Source-book of Biological Names and Terms,* 3rd ed. Springfield, IL: Charles C. Thomas, 1955.

Johnson, Charles W. *Bogs of the Northeast.* Hanover, NH: Univ. Press of New England, 1985.

Kilham, Peter. "The Biogeochemistry of Bog Ecosystems and the Chemical Ecology of *Sphagnum.*" *Michigan Botanist* 21 (1982): 159–68.

Kiviat, Erik, Lea Stickle, and Elise Heffernan. "Flora Re-survey after Four Decades in a New York Bog Lake." *Castanea* 84, no. 2 (2019): 289–309.

Kivinen, E., and P. Pakarinen. "Peatland Areas and the Proportions of Virgin Peatlands in Different Countries." In *Proceedings of the Sixth International Peat Congress,* by International Peat Congress. Duluth, MN: International Peat Society, 1981.

Kron, Kathleen A., and Walters Judd. "Phylogenetic Relationships within the *Rhodorea* (*Ericaceae*) with Specific Comments on the Placement of *Ledum.*" *Systematic Botany* 15, no. 1 (1990): 57–68.

Madsen, B. J. "Interaction of Vegetation and Physical Processes in Patterned Peatlands: A Comparison of Two Sites in Upper Michigan." PhD diss., University of Michigan, 1987.

Mandossian, Adrenne J. "Some Aspects of the Ecological Life History of *Sarracenia purpurea.*" PhD diss., Michigan State University, 1965. Microfilm.

McCormac, Jim S., and Gary Meszaros. *Wild Ohio: The Best of Our Natural Heritage.* Kent, OH: Kent State Univ. Press, 2009.

McCormac, Jim S., and Greg J. Schneider. "Floristic Diversity of a Disturbed Western Ohio Fen." *Rhodora* 96, no. 888 (1994): 327–53.

McCormac, Jim S., and Gregory Kennedy. *Birds of Ohio.* Aulburn, WA: Lone Pine Publishing, 2004.

McQueen, Cyrus B. *Field Guide to the Peat Mosses of Boreal North America.* Hanover, NH: Univ. Press of New England, 1990.

Moerman, Daniel E. *Native American Ethnobotany.* Portland, OR: Timber Press, 1998.

Moore, Peter D., and D. J. Bellamy. *Peatlands.* New York: Springer, 1973.

Muller, Walter H. *Botany a Functional Approach,* 2nd ed. New York: Macmillan, 1969.

Newmaster, Steven G., Allan G. Harris, Linda J. Kershaw. *Wetland Plants of Ontario.* Edmonton, AB: Lone Pine Publishing, 1997.

Pearce, Richard B., and James S. Pringle. "Joe Pye, Joe Pye's Law, and Joe-Pye-weed: The History and Eponymy of the Common Name Joe-Pye-weed for *Eutrochium* Species (*Asteraceae*)." *Great Lakes Botanist* 56 (2017): 177–200.

Peterson, Lee Allen. *Peterson Field Guides: Edible Wild Plants.* Boston, MA: Houghton Mifflin, 1977.

Pielou, Evelyn C. *After the Ice Age: The Return of Life to Glaciated North America.* Chicago: Univ. of Chicago Press, 1991.

Pojar, Jim, and Andy MacKinnon, eds. *Plants of the Pacific Northwest Coast: Washington, Oregon, British Columbia and Alaska.* Vancouver, BC: Lone Pine Publishing, 1994.

Pringle, James S. "An Introduction to Wetland Classification in the Great Lakes Region." *Bulletin New York Botanical Garden* 10 (1980): 1–11.

Rhoads, Ann Fowler, and Timothy A. Block. *The Plants of Pennsylvania: An Illustrated Manual,* 2nd ed. Philadelphia: Univ. of Pennsylvania Press, 2007.

Rice, Daniel, and Brian Zimmerman. *A Naturalist's Guide to the Fishes of Ohio.* Columbus: Ohio Biological Survey, 2019.

Roland, A. E., and E. C. Smith. *The Flora of Nova Scotia.* Halifax: Nova Scotia Museum, 1983.

Rosche, Larry, Judy Semroc, and Linda Gilbert. *Dragonflies and Damselflies of Northeast Ohio,* 2nd ed. Cleveland: Cleveland Museum of Natural History, 2008.

Rydin, Hakan, and John K. Jeglum. *The Biology of Peatlands: Biology of Habitats,* 2nd ed. Oxford: Oxford Univ. Press, 2013.

Schnell, Donald E. *Carnivorous Plants of the United States and Canada,* 2nd ed. Portland, OR: Timber Press, 2002.

Scott, Jane. *Botany in the Field.* Englewood Cliffs, NJ: Prentice-Hall, 1984.

Sears, Paul B. "Glacial and Post-glacial Vegetation." *Botanical Review* 1 (1935): 37–51.

Shane, Lind C. K. "A Pollen Sequence for a Bog in the Interlobate Area in Portage County Ohio." MM thesis, Kent State University, 1972.

Slack, Adrian. *Carnivorous Plants.* Cambridge, MA: MIT Press, 1979.

Smith, Huron H. "Ethnobotany of the Forest Potawatomi Indians." *Bulletin of the Public Museum of the City of Milwaukee* 7 (1933): 1–230.

———. "Ethnobotany of the Ojibwa Indians." *Bulletin of the Public Museum of the City of Milwaukee* 4, no. 3 (1932): 327–525.

Soper, James H., and Margret L. Heimburger. *Shrubs of Ontario.* Toronto: Royal Ontario Museum, 1985.

Sorenson, Eric R. *Ecology and Distribution of Ribbed Fens in Maine and Their Relevance to the Critical Areas Program,* Planning Report 81. Augusta: Maine State Planning Office, 1986.

Spearing, Ann M. "Cation-exchange Capacity and Galacturonic Acid Content of Several Species of

Sphagnum in Sandy Ridge Bog, Central New York State." *Journal of Bryology* 75 (1972): 154–58.

Stuckey, Ronald L., and Guy L. Denny. "Prairie Fens and Bog Fens in Ohio: Floristic Similarities, Differences, and Geographic Affinities." In *Geobotany II: Proceedings of the Geobotany Conference,* edited by Robert C. Romans, 1–34. New York: Plenum Press, 1981.

Swink, Floyd, and Gerould Wilhelm. *Plants of the Chicago Region,* 4th ed. Indianapolis: Indiana Academy of Science for the Morton Arboretum, 1994.

Tekiela, Stan. *Wildflowers of Michigan: Field Guide.* Cambridge, MN: Adventure Publications, 2000.

Theberge, John B., ed. *Legacy: The Natural History of Ontario.* Toronto: McCelland and Stewart, 1989.

Thompson, Elizabeth H., and Eric R. Sorenson. *Wetland, Woodland, Wildland: A Guide to the Natural Communities of Vermont.* Montpelier, VT: Nature Conservancy and Vermont Department of Fish and Wildlife, 2000.

Tiner, Ralph W., Jr. *A Field Guide to Coastal Wetland Plants of the Northeastern United States.* Amherst: Univ. of Massachusetts Press, 1987.

Turner, Nancy J., and Adam F. Szczawinski. *Edible Wild Plants of Canada, No. 2: Wild Coffee and Tea Substitutes of Canada,* 2nd ed. Ottawa: National Museums of Canada, 1984.

Voss, Edward G. *Michigan Flora, Part 1: Gymnosperms and Monocots,* Cranbrook Institute of Science Bulletin 55. Ann Arbor: Univ. of Michigan Herbarium, 1972.

Voss, Edward G., and Anton A. Reznicek. *Field Manual of Michigan Flora.* Ann Arbor: Univ. of Michigan Press, 2012.

Walkinshaw, Lawrence H., and Mark A. Wolf. "Distribution of the Pine Warbler and Its Status in Michigan." *Wilson Bulletin* 69, no. 4 (1957): 338–51.

Wallner, Jeff, and Mario J. DiGregorio. *New England's Mountain Flowers: A High Country Heritage.* Missoula, MT: Mountain Press, 1997.

Wang, B., and Y.-L. Qiu. "Phylogenetic Distribution and Evolution of Mycorrhizas in Land Plants." *Mycorrhiza* 16 no. 5 (2006): 299–363.

Weatherbee, Ellen E. *Guide to Great Lakes Coastal Plants.* Ann Arbor: Univ. of Michigan Press, 2009.

Wells, James R., Fredrick W. Case Jr., and T. Lawrence Mellichamp. *Wildflowers of the Western Great Lakes Region.* Bloomfield Hills, MI: Cranbrook Institute of Science, 1999.

Werier, David. "Catalogue of the Vascular Plants of New York State." *Memoirs of the Torrey Botanical Society* 27 (2017).

Westbrooks, Randy G., and James W. Preacher. *Poisonous Plants of Eastern North America.* Columbia: Univ. of South Carolina Press, 1986.

Worley, Ian A., and Janet Sullivan. *A Classification Scheme for the Peatlands of Maine,* Resource Report 8. Burlington: Vermont Agricultural Experiment Station, 1980.,

Zwinger, Anna H., and Beatrice E. Willard. *Land above the Trees: A Guild to American Alpine Tundra.* Tucson: Univ. of Arizona Press, 1972.

Index

Page references in italics refer to illustrations.

outside fen perimeter, 103–5
outwash plains, 9
Owens Fen/Liberty Fen State Nature Preserve (Ohio), *96*
oxidized rhizosphere, 85
oxygen, 7, 24
Oxypolis rigidor. See cowbane (*Oxypolis rigidor*)

pannes, 108
paper (white) birch (*Betula papyrifera*), 34, *66*, 68
Parnassia glauca. See grass-of-Parnassus (*Parnassia glauca*)
patterned fens, 105–7
Pearce, Richard B., 93
peat: carbon dating of, 73–74; defined, 1–2; fibric, hemic, sapric peat layers, 23
peat bogs: defined, 1; oligotrophic peatlands (kettlehole sphagnum peat bogs), 75 (*see also* kettlehole sphagnum peat bogs); raised bogs, 17–18, *18*, 53, 75
peatlands, vii–x, 1–3; bogs and Celtic terminology, vii; Celtic terminology for bogs, vii; defined, 1; geogenous, earth-originating peatlands, 18 (*see also* rich fens); kettlehole sphagnum peat bogs, defined, vii; kettlehole sphagnum peat bogs vs. rich fens, x; peat, defined, 1–2; prehistoric human bodies found in, 2–3, 24; as products of continental glaciation, 5–15; resources on scientific classifications of, ix; rich fens, defined, vii, 75–76, 77; in southern Great Lakes region, vii; in upper Great Lakes region, vii–ix. *See also* kettlehole sphagnum peat bogs; Pleistocene Ice Age; rich fens
pH: of Great Lakes, 108; of kettlehole sphagnum bogs, 75–76; and marl formation, 77–79; of rich fens, 75–76, 80
Phlox maculata (spotted phlox), 91
Physocarpus opulifolius (ninebark), 98–99
Picea, 68. *See also* black spruce (*Picea mariana*)
Picea glauca (white spruce), 34
Pickaway County (Ohio), Stages Pond State Nature Preserve, 33
pink lady's-slipper orchids (stemless moccasin flower orchids, *Cypripedium acaule*), 70, *70*
pin oak (*Quercus palustris*), 33
Pinus resinosa (red pine), 34
Pinus strobus. See white pine (*Pinus strobus*)

pitcher plants, 44. *See also* northern pitcher plant (*Sarracenia purpurea*)
Plant Geography on a Physiological Basis (Schimper), 25
plant zones of rich fens, 81–103; boreal rich fens, 100–103, *100–103;* fen meadow, 81, *89–93,* 89–94; open marl flats, 81–89, *82–88;* prairie fens, 94–97, *95–97;* swamp forest, 81; tall shrub zones, 81, 97–99, *98, 99;* transition zones, 81
Plathanthera blephariglottis (white-fringed orchid), 50–51
Pleistocene Ice Age, 5–15; and boreal vegetation, 12–13; deep-sea sediment from, 6–7; Devensian glaciation, 13–15; glacial ice development and flow, 8–12, *10–11;* glaciation causes, 5–6; vegetative composition and transitions during, 29; Wisconsinan glaciation, 6
podgrass (*Scheuchzeria palustris*), 39, *40*
Pogonia ophioglossoides. See rose pogonia (*Pogonia ophioglossoides*)
poison sumac (*Toxicodendron vernix*), *63,* 63–65, *64,* 71, 97, 117
pollen profiles, of kettlehold bogs, 73–74
pollination, 47–51, 58, 63
pom-pom peat moss (*Sphagnum wulfianum*), 69
poor fens, 17–18
Populus tremuloides (quaking aspen), 34
Portage County (Ohio), kettlehole sphagnum peat bogs in, 34
prairie fens, 94–97, *95–97*
Prairie Road Fen State Nature Preserve, *xiii*
Pringle, James S., 93
proglacial lakes, 34
purple chokeberry (*Aronia prunifolia*), 65, *65*
purple meadow-rue (*Thalictrum dasycarpum*), 94
purple-stemmed aster (*Symphyotrichum puniceum*), 94
pussy willow (*Salix discolor*), 97, *101,* 117
Pye, Joe (Shauqueathqueat), 93–94

quaking aspen (*Populus tremuloides*), 34
quaking bogs, *38,* 39, 59, 89–90
queen-of-the-prairie (*Filipendula rubra*), 95, *97*
Quercus bicolor (white oak), 33
Quercus palustris (pin oak), 33

radiocarbon dating, 73–74
rain-fed (ombrotrophic) bogs, 14
raised bogs, 17–18, *18,* 53, 75

Ratibida pinnata. See gray-headed coneflower (*Ratibida pinnata*)
rattlesnake. *See* eastern massasauga rattlesnake (*Sistrurus catenatus catenatus*)
red maple (*Acer rubrum*), 34, 69, 117
red pine (*Pinus resinosa*), 34
red-winged blackbirds (*Agelaius phoeniceus*), *112*
reptiles, 112–15, *114*
Rhamnus alnifolia (alder-leaved buckthorn), 91
Rhamnus cathartica (common buckthorn), 91
rhizomes, 36
Rhododendron groenlandicum. See Labrador tea (*Rhododendron groenlandicum*)
Rhynchospora alba. See white beak-rush (*Rhynchospora alba*)
Rhynchospora capillacea (hair beaked rush), 87
rice cut grass (*Leersia oryzoides*), 105
rich fens, 77–108; boreal rich fens, 100–103, *100–103;* coastal fens, 107–8; defined, vii, 18, 75–76, 77; vs. kettlehole sphagnum peat bogs, x; landscape distribution of, 80–81; limiting factors in, 80; and marl formation, 77–79, *78, 79;* minerotrophic rich fens, defined, 75–76; natural succession in, 81, 103; northern fen communities, 105–8, *106, 107;* outside fen perimeter, 103–5; pannes, 108; patterned fens, 105–7; pH of, 75–76, 80; plant zones of, 81–103. *See also* plant zones of rich fens
Riddell, John L., 92
Riddell's goldenrod (*Solidago riddellii*), 91–92
root/fungus associations, *26,* 26–27
Rosa palustris. See swamp rose (*Rosa palustris*)
Rose Family (*Rosaceae*): marsh cinquefoil (*Comarum palustre*), *40;* purple chokeberry (*Aronia prunifolia*), 65, *65;* swamp rose (*Rosa palustris*), 1, 71, 105. *See also* shrubby cinquefoil (*Dasiphora fruticosa*)
rose pogonia (*Pogonia ophioglossoides*), *48,* 49–50, 87, 103
round-leaved sundew (*Drosera rotundifolia*), 39, 42, *43,* 87, *88,* 102, 103
royal fern (*Osmunda regalis*), 69, *69*
Rudbeckia fulgida (showy coneflower), 91
Rudbeckia hirta (black-eyed Susan), 91
Rush Family. *See individual rushes*
rusty claw-leaved feather moss (*Drepanocladus revolvens*), 89